STANSTED AIRPORT

THROUGH TIME

Charles Woodley

AMBERLEY PUBLISHING

First published 2011

Amberley Publishing
The Hill, Stroud
Gloucestershire, GL5 4EP

www.amberley-books.com

Copyright © Charles Woodley, 2011

The right of Charles Woodley to be identified as the
Author of this work has been asserted in accordance
with the Copyrights, Designs and Patents Act 1988.

ISBN 978 1 4456 0091 8

British Library Cataloguing in Publication Data.
A catalogue record for this book is available from
the British Library.

Typeset in 9.5pt on 12pt Celeste.
Typesetting by Amberley Publishing.
Printed in the UK.

Introduction

London (Stansted) Airport, in common with many of our UK airports, began life in the Second World War as a military airfield. During 1942, the United States Army Air Force commenced construction on a site on a plateau some two miles south-east of the village of Stansted Mountfitchet in Essex. In June 1943, it was opened as an Advanced Air Depot for the maintenance and storage of the medium bombers of the 9th Air Force, but from March 1944 the B-26 Marauder twin-engined bombers of the 344th Bombardment Group began flying combat missions to France from Stansted. By the time they were relocated to forward airfields in France they had flown 146 missions for the loss of twenty-six aircraft.

After the end of hostilities and the departure of the USAAF the airfield was handed over to the Air Ministry to be placed on a Care and Maintenance basis. By early 1946, all flying had ceased and the hangars were used to store and dispose of war surplus equipment from airfields all over East Anglia. Once this was complete the Air Ministry handed over the airfield to the Ministry of Civil Aviation, and a new civilian role had to be found for Stansted.

Even before the last RAF personnel had vacated the airfield it had been adopted as a base by some of the very first postwar UK charter airlines. One of these was London Aero & Motor Services, which used converted Handley Page Halifax bombers as freighters, and other early residents were Kearsley Airways, Skyways Ltd, and William Dempster Ltd, using Avro Tudors for low-cost passenger services to Johannesburg. The airport was also much used for trooping flights to Britain's garrisons in the Far East and Middle East, and Mr Freddie Laker's engineering company, Aviation Traders Engineering, established a maintenance base at Stansted that later went on to design and produce the Carvair car-ferry aircraft. Stansted also benefitted from the residency of the government-run Civil Aviation Flying Unit with its fleet of aircraft, and the Fire Service Training Centre during its fledgling years.

1964 saw the first of many announcements regarding Stansted's proposed future role as London's third airport (after Heathrow and Gatwick), and its status was enhanced in 1966 when it was taken under the control of the newly-formed British Airports Authority. The arrival of airlines such as Ryanair and Air UK led to a welcome growth

in aircraft movements and passenger numbers, and a further boost was provided by the choice of Stansted as their base by new low-cost carriers Go Fly and Buzz. Their success was short-lived however, as the competition from Ryanair and Easyjet proved too much for them and led to their takeover by these airlines. Over the years many attempts were made to operate successful scheduled transatlantic services from Stansted, by established operators such as American Airlines, and by start-up airlines such as Highland Express, Eos Airlines, and MAXjet, and the airport almost became the initial UK departure point for Freddie Laker's Skytrain service to the USA, but none of these companies were able to able to sustain services on an economical basis for very long.

Despite these setbacks Stansted continued to grow, and has finally become recognised as a major airport for the south and east of England. This was underlined in 1991 by the opening of an award-winning new terminal building with its own rail link to central London. The continual expansion of services has led to the need for a second runway, and the 'go-ahead' for this seemed to be all set, until a General Election and a change of government led to the announcement in May 2010 that the BAA was withdrawing its application for a second runway as it was unlikely to be approved in the near future. Perhaps an improvement in Britain's economic situation will enable the new runway to be built at some future date. In the meantime, Stansted will no doubt continue to work around such obstacles as it has done so many times throughout its history.

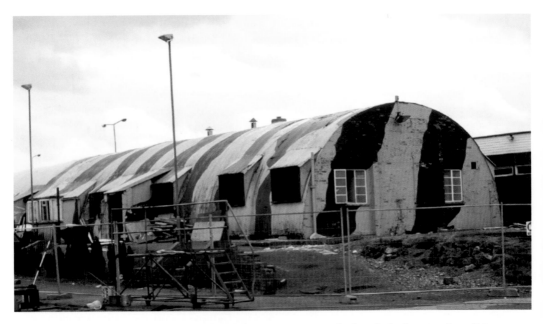

The Nissen hut that was once the original passenger terminal, shortly before its demolition. (George Pennick)

Acknowledgements

Many people have very kindly assisted me with this book, by sending me images or allowing me to use their images posted onto websites, by supplying information, and by offering encouragement and support. My thanks go to:

Eric Melrose, Martin Bowman at Kearsley Airways, Melvyn Nice at BAA Stansted, Dietrich Eggert, Brian Doherty, Dan Nicholson, Tom Singfield, Dave Welch, Derek Heley, Richard E. Flagg, Allen Clarke, Tony Doyle, George Pennick, various contributors to the Air-Britain AB-IX website, members of the Airfield Information Exchange, and members of the Airfield Research Group. If there is anybody I have missed, my apologies and thanks.

Sources of Reference

The following books have proved invaluable as sources of reference, and are recommended for further reading on Stansted airport and its airlines past and present:

Stansted Airport, Nathan Kosky, Sutton Publishing Ltd, 2000.
The Stansted Experience, John F. Hamlin, GMS Enterprises, 1997.
Stansted – The War Years, Derek White and Reg Robinson, Stansted Airport Ltd, 1992.
British Independent Airlines Since 1946 (first edition), A. C. Merton Jones, MAS and LAAS International, 1976.

Wartime Service

As part of a 1941 agreement between British Prime Minister Winston Churchill and US President Roosevelt, many possible sites for airfields were handed over to the USA on ninety-nine-year leases. One of these was situated on a plateau two miles south-east of the village of Stansted Mountfitchet in Essex, some six miles from Bishops Stortford, and thirty-four miles north-east of London. Early in 1942, the decision was taken to build a US airbase there, initially for use as a storage depot and repair facility for USAAF bombers, under the designation Station 169. Construction work was entrusted to the 825th and 850th Engineers Batallions (Aviation), with a target completion date of July 1943. The base was to be built with the standard three-runway triangular layout, with the main runway 05/23 being 6,000ft in length, and subsidiary runways 12/30 and 18/36 being 1,800ft long and 1,500ft long respectively. Each runway was to be 150ft wide and they were to be surrounded by a circular perimeter track to Class A standard, which was to have an initial fifty hardstandings, all but two of the 'loop' type. Four T2 type hangars were to be erected instead of the usual two, with one pair located together at the Technical Site, one on the north side near Burton End, and the fourth not far from the A120 main road between Bishops Stortford and Braintree. A series of dispersed sites of living accommodation was to be constructed to the east of the base.

The first American unit to arrive was the 817th Engineer Aviation Batallion on 14 July 1942. By the time they departed for training for combat service in November 1942 they had completed about half of the runways and perimeter tracks. Their work was continued by the 825th Engineer Aviation Batallion, which arrived during late September and October 1942. They completed the runways and roads and started work on the control tower, fire station and motor transport depot before leaving in their turn on 10 November 1943 for Algeria. By the end of 1942, the four T2 hangars, the control tower, numerous Nissen huts, over forty hardstandings, the armoury and bomb dumps were all in various stages of construction. The first recorded use of the still incomplete and non-operational runway took place on 26 February 1943 when a Short Stirling bomber of 214 Squadron RAF made an emergency landing at Stansted on the way back from a raid on Nuremberg. The Stirling overshot the runway, struck trees at the end and was destroyed, but the crew survived relatively unscathed. On 20 May 1943, the 850th

Engineer Aviation Batallion arrived and stayed until April 1944. Their first construction project was the base hospital, followed by a recreation centre on a site adjacent to the airfield at the Takeley end as part of a new Tactical Air Depot complex. Stansted was originally intended to house heavy bombers such as the B-17 Flying Fortress but a change in policy resulted in the 8th Air Force deploying B-26 Marauder medium bombers at its new airfields in Essex. The first of these arrived at Andrews Field, Earls Colne, Boxted and Chipping Ongar airfields in June 1943, and in July the depot facilities at Stansted were made available for the 30th Air Depot Group to provide maintenance services for the medium bomber force. During this period the airfield was briefly and unofficially also known as George Washington Field. On 7 August 1943, the Air Depot was formally opened, and by 17 August it was sufficiently complete to be able to accept aircraft movements. Prior to this, however, the airfield had received another unexpected visitor when a B-17F landed on 6 July despite the absence of air traffic control or crash rescue facilities. In October 1943, the base was transferred to the 9th Air Force, along with all the B-26 groups in England and their airfields, as part of the preparations for the eventual invasion of France. Known from early 1944 as the 2nd Tactical Air Depot, Stansted was the largest Ninth Air Force base in the region, and was tasked with providing comprehensive aircraft supply, assembly, servicing and maintenance for all the twelve Ninth Air Force groups in Essex.

On 15 February 1944, the first ground elements of the 344th Bombardment Group squadrons 494, 495, 496 and 497, known as the 'Silver Streaks', moved in. Five days later the first of their B-26s arrived on delivery from the USA. After making training flights the Group aircraft flew a diversionary sortie to near the French coast on 29 February, and flew their first combat mission on 6 March, to Bernay St Martin airfield in France. On the morning of D-Day, 6 June 1944, fifty-six Marauders took off shortly after 0400 to bomb coastal batteries on the Cherbourg Peninsular and near the Normandy invasion beachhead. During the next seven months, 146 missions were flown from Stansted and twenty-six aircraft were lost. In September 1944 the squadrons departed for new bases in France and combat operations from Stansted ceased. However, the Air Depot continued in use for the storage of over 200 B-17s, P-47 Thunderbolts and other types until October, when it followed the rest of the Ninth Air Force to France. The airfield and its facilities were then handed over to the Air Service Command of the US Tactical Air Force. From January 1945 onwards the stored aircraft were flown out or otherwise disposed of. Following the end of hostilities in Europe Stansted was used as a rest centre for American troops, including the 82nd and 100th Airborne Units, in transit home to the USA. In August 1945, the USAAF withdrew from Stansted and the airfield was handed over to the British Air Ministry on a 'care and maintenance' basis. The runways and taxiways were tarred and sanded, presumably to preserve their surfaces, and large white crosses were painted on the ends of the runways to denote that they were out of use. On 16 August 1945, RAF Maintenance Unit No. 263 arrived to take over the airfield as RAF Stansted Mountfitchet. They reportedly found the site in an appalling condition, and everyone had to be accommodated in the former Officers' Club

while a thorough cleaning operation was carried out. The hangars were used to store and dispose of war surplus equipment from other closed airfields around East Anglia, and by October 1945 over 800 tons of this was passing through Stansted each week. To assist them in this work the RAF personnel were joined by 400 German prisoners of war, who were resident there until the last one left on 14 August 1947. In December 1947, the Maintenance Unit conducted the first of several public auctions of war surplus material, disposing of 1,380 tons of material for £15,516 in total. Towards the end of 1948 almost all of the buildings used for storage had been emptied. The RAF contingent had by then been reduced to two NCOs and fourteen 'other ranks', and the decision was taken to close RAF Stansted Mountfitchet. On 1 January 1949, No. 263 Maintenance Unit was disbanded and the RAF presence at the airfield ceased. The airfield was decommissioned and officially transferred from the Air Ministry to the Ministry of Civil Aviation by the end of the month.

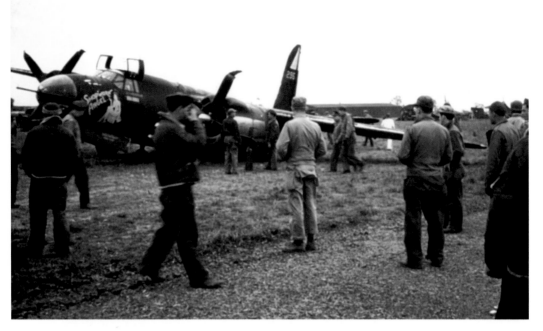

B-26B medium bomber 42-95917 'Shopworn Angel' of the 495th BS, 344th BG, after its crash-landing at Stansted in 1944. (BAA)

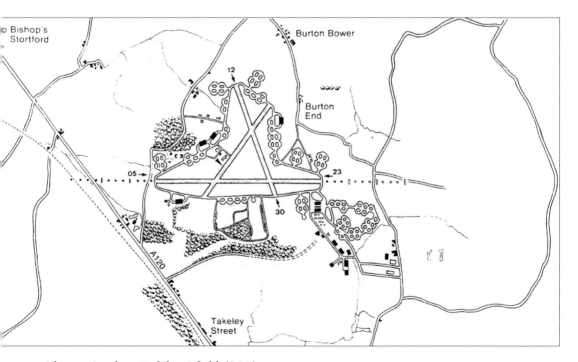

The wartime layout of the airfield. (BAA)

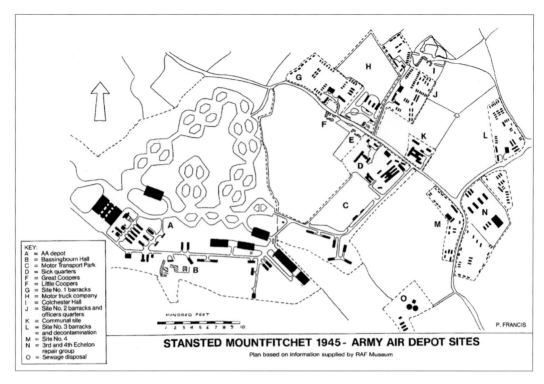

KEY:
A = AA depot
B = Bassingbourn Hall
C = Motor Transport Park
D = Sick quarters
E = Great Coopers
F = Little Coopers
G = Site No. 1 barracks
H = Motor truck company
I = Colchester Hall
J = Site No. 2 barracks and
 officers quarters
K = Communal site
L = Site No. 3 barracks
 and decontamination
M = Site No. 4
N = 3rd and 4th Echelon
 repair group
O = Sewage disposal

HUNDRED FEET
1 2 3 4 5 6 7 8 9 10.

P. FRANCIS

STANSTED MOUNTFITCHET 1945 - ARMY AIR DEPOT SITES
Plan based on information supplied by RAF Museum

The layout of the US Army Air Depot sites in 1945. (BAA)

Some of the wartime Nissen huts still lingering on in 1980s. (Paul Francis)

LIST OF UNITS STATIONED AT STANSTED

5th Airdrome Squadron

10th Supply Platoon

15th Veterinary Detachment

17th Veterinary Section

16th Air Depot Group
 Headquarters & Headquarters Squadron
 90th Supply Squadron
 96th Repair Squadron

21st Mobile Rubber Repair Squadron

25th Mobile Reclamation & Repair Squadron

30th Air Depot Group
 Headquarters & Headquarters Squadron
 30th Supply Squadron
 30th Repair Squadron

34th Supply Platoon

36th Supply Platoon

37th Station Complement Squadron

40th Station Complement Squadron

40th Air Depot Group
 Headquarters & Headquarters Squadron
 40th Supply Squadron
 40th Repair Squadron

41st Mobile Rubber Repair Squadron

46th Mobile Reclamation & Repair Squadron

63rd Station Complement Squadron

74th Service Squadron

88th Air Depot Group

91st Air Depot Group
 86th Repair Squadron
 94th Supply Squadron

170th Reinforcement Company

128th Reinforcement Battalion

198th Medical Dispensary, Aviation Regional Station

303rd Station Complement Squadron Detachment 3

334th Bombardment Group
 Headquarters & Headquarters Squadron
 494th Bombardment Squadron
 495th Bombardment Squadron
 496th Bombardment Squadron
 497th Bombardment Squadron

416th Air Depot Group

429th Air Depot Group Platoon

430th Air Depot Group Platoon

826th Aviation Battalion

850th Aviation Battalion

861st Corps of Engineers Battalion

909th Depot Company Signal Corps

919th Depot Company Signal Corps

1196th Military Police Company

1201st Military Police Company

1256th Military Police Company

1330th Engineer General Service to Regiment (Colored)
 Headquarters & Headquarters Co. 2nd Battalion

1496th Medium Maintenance Co. Q. Ordinance

1605th Supply & Maintenance Co. Ordinance

1703rd, Medium Maintenance Co. Q. Ordinance

1815th Supply & Maintenance Co. Ordinance

1923rd Truck Company

1957th Depot Company, Ordinance

2004th Maintenance Company, Ordinance

2014th Firefighter Platoon

2058th Firefighter Platoon

2063rd Truck Company

2076th Truck Company

2086th Truck Company

2198th Truck Company

2202nd Truck Company

2203rd Truck Company

2204th Truck Company

2205th Truck Company

2206th Truck Company

2207th Truck Company

2208th Truck Company

2209th Truck Company

2210th Truck Company

2487th Truck Company

Detachment B, 331st Station Complement Squadron

Detachment B, 984th Military Police Company

Detachment C, 879th Signal Company

Detachment E, 908th Signal Company

Base Air Depot Area
 Headquarters & Headquarters Squadron
 Detachment K
 Detachment N

List of the US units stationed at Stansted during the Second World War. (BAA)

The First Civil Operations

In 1946, while the airfield was still being used by the RAF as a storage depot, London Aero & Motor Services obtained a twenty-one-year lease on certain areas of Stansted by arrangement with the Air Ministry and the Ministry of Civil Aviation. LAMS had been founded on 17 July 1946 by Dr Graham Humby, and the company initially used various light aircraft for charter flights out of its base at Elstree aerodrome. However, the increasing demand for freight charter flights led Dr Humby to purchase six Handley Page Halton C.VIII transport conversions of the Halifax bomber during that summer. It soon became apparent that Elstree was too small for these four-engined machines, and during the search for a more suitable base Captain Dennis Leach was responsible for the first civilian aircraft movement at Stansted when he landed to check out the facilities for possible use by his airline. On 14 December 1946, it transferred its base to Stansted. Its initial operations were hampered by the lack of customs facilities at Stansted, and the airline was also responsible for providing its own air traffic control service, refuelling facilities and emergency services. At that time four Halifaxes were in active service, but the fleet was expected to grow to fifteen examples. Early work for the aircraft included the transportation of fourteen tons of medical supplies to Belgrade aboard two machines. The company was averaging around four aircraft movements each day at Stansted, but flights still had to route via Heathrow in each direction for customs clearance. Dr Humby estimated that three customs officers could handle this volume of traffic, and even offered to pay their salaries and provide them with living accommodation. Other UK and overseas airlines were requesting permission to operate into and out of Stansted, and the state airline BEA was considering using Stansted as the regular terminus for its contemplated cargo division, but it was to be the early summer of 1947 before customs facilities were eventually provided by the Ministry of Civil Aviation. On 23 April 1947, LAMS commenced world-wide 'tramping' operations when Halifax G-AIWT *Port of Sydney* departed Stansted bound for New Zealand, a trip that was to bring reward in the form of a series of freight charters to that country via Iceland and North America. The aircraft returned to Stansted six weeks later, its arrival on 5 June 1947 coinciding with the official opening of customs facilities at the airport. Among the return load was a consignment of 14,000lb of beef dripping, a gift

to the people of Britain from the people of Australia. On the following day Halifax G-AHZK took off for Bergamo on the first international service to operate direct from Stansted without a stop for customs clearance. On 25 September that year LAMS was amalgamated with the holding company of the South African charter airline Alpha Airways. Alpha's sole Halifax became part of the LAMS fleet and regular passenger services were operated between Stansted and Johannesburg, the journey taking four days in each direction with nightstops at Malta, Khartoum and Nairobi. A stewardess was carried to look after the passengers, and up to 5,000lb of cargo could be carried in a pannier beneath the fuselage. Most of the company's revenue, however, was derived from its contracts to carry soft fruit from Italy into Stansted as part of the Italian Government War Reparations Scheme. Up to three flights from Bergamo and Verona were operated on every day except Saturdays, and during July of 1947 the LAMS fleet of seven Halifaxes flew some 435 hours on this work. As autumn approached, however, the fruit flights tailed off and other work had to be sought out. Urgently needed blood plasma was carried from Stansted to Cairo and a flight was made to Johannesburg with twelve pedigree dogs in a Halifax specially equipped with kennels. In December 1947, Dr Humby was diagnosed with tuberculosis and ordered to rest. Without his active input the company faltered and operations began to be wound down. The Johannesburg service stopped at the end of December 1947 and by February 1948 most of the fleet was idle at Stansted. Alpha Airways withdrew its financial interest, and on 19 April 1948 a petition for compulsory winding up was presented, but the hearing was adjourned to enable limited fruit-carrying services to resume in May. Six Halifaxes were taken over by Stansted Airport Limited on lease and were flown in LAMS livery, but by July 1948 most of these flights had ceased. On 12 July, the remaining aircraft were grounded and a compulsory winding up order was issued by the High Court, just a week before the start of the Berlin Airlift, participation in which might have restored the company's fortunes.

Kearsley Airways was founded on 9 April 1947 and initially operated light charters with a single Percival Proctor aircraft, but at the end of that summer the company took delivery of its first Douglas Dakota G-AKAR, which arrived at Stansted on 31 October. Within thirty hours it was airborne on its first revenue service, carrying medical supplies and aircraft spares to Delhi on behalf of the UK state airline BOAC. For the summer of 1948 Kearsley had available for hire two Dakotas and the original Proctor. Both Dakotas were despatched to Germany to take part in the Berlin Airlift, returning in November to Stansted, where they were joined by a third example in early December. In January 1949, Kearsley received an urgent call from the other state airline BEA. Spare parts were needed at Wunsdorf in Germany for a grounded Avro Lancastrian tanker aircraft of Flight Refuelling Ltd. Within fifty-five minutes a Dakota was airborne and heading for Bovingdon in Hertfordshire to pick up passports and papers, which had been rushed there by road from the London office. From Bovingdon the aircraft flew to the Flight Refuelling base at Tarrant Rushton, where it was loaded with spares, including tailfins, rudders and elevators and a Merlin engine. By the autumn of 1949, an engineering base

had been established at Stansted, and on 10 November one of the Dakotas took part in a demonstration of the Irvin Airchute barometric automatic release parachute. Major T. W. Williams jumped from the Dakota at 15,000ft over Stansted with the barometric release set to function at 6,000ft. The canopy opened within 200ft of the target height. Early in 1950, Kearsley Aviation took the decision to dispose of the aircraft fleet, and all charters ceased in March of that year. The Dakotas were sold but the company continued in business, concentrating its energies on expanding its aircraft maintenance operation at Stansted. Three companies were set up to offer a variety of services, Kearsley Airways Ltd, Kearsley Airways (Engineering) Ltd, and Kearsley Aero Chemicals Ltd. Throughout the 1950s and 1960s much work was carried out for government ministries, including ARB-approved overhaul and repair of electrical and hydraulic aircraft components, and the company is still active today, although based at new premises outside the airfield boundaries. Another company to establish itself briefly at Stansted in the immediate post-war years was World Air Freight Ltd. From November 1947 freight charters were operated with a single Halifax. A second example joined the fleet on 28 January 1948, but at the end of February the airline's operating base was transferred to Bovingdon.

By 1948 it was thought that Heathrow airport would have difficulty coping with the additional charter traffic in summer and Stansted was considered, along with Gatwick, Blackbushe and Fairlop (a wartime fighter base near Ilford) as the main supplementary airport for London. In the event Gatwick was chosen for this role, with Blackbushe being nominated as the favoured diversion airport for Heathrow because of its relative proximity to London. Despite these snubs, Stansted was allocated the sum of £30,000 by the government on 1 March 1949, the money to be used for upgrading work on certain buildings. Most of the expenditure went on the installation of VHF radio facilities, a general reorganisation of the control tower, the upgrading of navigation aids and resurfacing of runways and the perimeter track. In 1951, the Black Boy Pond in the centre of the airfield was filled in, a job that took some three weeks. During 1950, the Ministry of Civil Aviation relocated its Civil Aviation Flying Unit to Stansted from previous bases at Gatwick and Prestwick. The initial fleet included Tiger Moths, Chipmunks, Austers, Airspeed Consuls, Avro 19s and a Miles Gemini. In April 1951, the contract for the maintenance, overhaul and modification of the fleet was awarded to Helliwells Ltd.

On 10 April 1951, Halifax G-AGZP of the Lancashire Aircraft Corporation made an emergency landing at Stansted after an engine became detached while it was inbound to the company's Bovingdon base. LAC was the last British commercial operator of the Halifax and in the summer of 1951 it started to use Stansted as the terminus for flights operated by its new fleet of Avro Yorks. Also, during that summer, William Dempster Ltd transferred its operating base from Blackbushe to Stansted. The company used two Avro Tudor 5s on low-fare services to Johannesburg, and a Dakota for general charter work. At the end of 1953 the airline decided to suspend all flying operations. The grounded Tudors remained at Stansted, having been acquired for spares by Aviation Traders Ltd. Another Tudor operator was Surrey Flying Services, which moved into

Stansted in October 1951. By the end of 1952 it had been absorbed into Aviation Traders Ltd, which had leased a hangar at Stansted and cleared out several red London Transport buses and Green Line coaches stored within. At the end of 1951, ten Miles Marathon aircraft owned by the Ministry of Supply arrived at Stansted for storage in another hangar until this too was acquired by Aviation Traders in 1952. The Marathons were then removed and scrapped.

On 6 August 1951, the Handley Page HP88 research aircraft arrived at Stansted. This crescent-wing jet had been built to test various features of the future Victor bomber and was at Stansted to carry out a series of airspeed indicator calibration flights prior to its appearance at the Farnborough air show. On 26 August 1951, it had been airborne for ten to fifteen minutes and was making a run at 300ft above the main runway at Stansted when it suffered structural failure and broke up, with the loss of its pilot, D. J. P. Broomfield DFM.

In 1952, Skyways of London transferred its operating base and some two hundred staff from Bovingdon to Stansted and commenced trooping flights with Avro Yorks. This airline was to establish a large maintenance base at Stansted, incorporating three hangars, and its arrival brought about the re-introduction of customs facilities that had been suspended. On an average day Skyways operated one inbound and one outbound trooping flight, but at peak periods this frequency could be doubled. On 2 July 1952, Skyways began carrying troops from Stansted to Jamaica via Keflavik, Gander and Bermuda in a total flying time of twenty-seven hours. By October 1952, Skyways had a fleet of up to eight Yorks in service on trooping flights, and in April 1953 the airline was awarded another Air Ministry contract, this time for eleven trips to Nairobi. On the return legs the Yorks routed via several Middle East bases, picking up troops for leave in the UK. On 13 September 1952, a Battle of Britain air display was held at Stansted. Participants included twenty F-84G Thunderjets of the US 77th Fighter Squadron based at Wethersfield, five Royal Canadian Air Force F-86s from North Weald, and a new Canberra from 231 OCU at Bassingbourn. Pleasure flights in a DH Rapide biplane were on offer to the public.

In 1953, the Ministry of Aviation announced that Gatwick had been selected for development as a major international airport for London, second only to Heathrow. Back in 1949 the government of the day had stated that it had no intention of developing Gatwick, but the 1953 spokesman said that 'since that time the re-armament programme has commenced, and Stansted aerodrome, which it was hoped would be used as an alternative to London Airport, is now practically unusable for civil aircraft'. It was deemed to be on the wrong side of London, and its growth was handicapped by the large volume of military air traffic from nearby USAF and RAF bases using East Anglian airspace. Stansted was to be kept open only until the development of Gatwick had been completed, then it faced the likelihood of closure. Despite this gloomy prognosis the Stansted branch of the Royal Air Force Association still went ahead with another air display on 26 September 1953. Some 7,000 spectators paid the 2s admission price to see a display, which was opened by a formation of Meteors of 601 Squadron Royal Auxiliary

Air Force from nearby North Weald. The new De Havilland Heron 2 civil transport was demonstrated, followed by a formation of Royal Canadian Air Force Sabres from North Luffenham. Then came a solo Gloster Meteor, 'crazy flying' by a Tiger Moth, and parachute drops from a tethered balloon of the 10th Batallion, Parachute Regiment. The second half of the display was opened by four Canberras from RAF Binbrook, and a series of low-level runs was made by Thunderjets from Wethersfield. A 'crash rescue' was demonstrated by the Fire Section, and pleasure flights in a DH Rapide were again on offer. To round off the day there was a dance to the sound of Freddie Wilson's Band in the evening. On 31 October 1953, Skyways of London operated a proving flight for their 'Crusader' Colonial Coach fare service from Stansted to Nicosia via Malta. The first revenue service took place on 11 November, and from that date flights were operated on alternate Wednesdays by Avro Yorks. The fare was £41 10s 0d one way or £75 for the round trip. Because Cyprus was then in the sterling currency area Skyways was able to offer a two-week stay in a luxury hotel and return flights for a package price of around £100. The Yorks took over fourteen hours to get to Nicosia, but in September 1954 Skyways acquired the first example of an eventual fleet of 68-seat Hermes airliners from BOAC, and the journey became quicker and more comfortable.

From 1 April 1954, the contract for the maintenance of the aircraft of the Ministry of Transport and Civil Aviation Flying Unit passed to Aviation Traders (Engineering) Ltd at Stansted. The fleet at that time consisted of five De Havilland Doves, three Percival Princes, five Airspeed Consuls, a Miles Gemini and a Chipmunk. As well as caring for these aircraft the comprehensive hangar and workshop facilities of Aviation Traders also looked after the fleet of its associate company Air Charter Ltd, which comprised Avro Tudors and Yorks and Bristol 170s. Air Charter Ltd had been intending to inaugurate passenger services with their Avro Supertrader conversion of the Tudor on 7 February 1954, but ice on the Stansted runway forced a postponement of the services to Hamburg until the following week. The type was also used on Colonial Coach services to Idris and Lagos from Stansted, and from the mid-1950s it also operated a cargo service to Woomera in Australia in support of the UK government's space programme. In January 1953, Scottish Airlines had commenced an Air Ministry contract to carry RAF air cadets from Stansted to Montreal for training. By the end of that first year over 1,700 cadets had been transported. On 22 September 1954, Avro York G-ANRC, with five crew and forty-four passengers aboard, swung violently to the left during its take-off run at Stansted. The pilot over-corrected and the York then swung to the right. Take-off was abandoned but the left main undercarriage collapsed. There were no fatalities but the aircraft was burnt out. When the contract came to an end, Scottish Airlines was awarded further contracts for trooping flights to the Egyptian Canal Zone.

Following the Korean War cease-fire Stansted was again chosen by the US government as a possible base, this time for use by Strategic Air Command in the event of a Europe-based war against the Soviet Union. From February 1954, 803rd Engineer Aviation Batallion engineers lengthened the main runway to 10,165ft and added new taxiways and hardstandings for possible use by nuclear-armed bombers. During this

work the northern taxiway was widened and strengthened so that it could be used as a temporary runway by the trooping flights which continued to operate from the airfield. The upgraded main runway was handed over by the US Air Force to the MTCA on 30 August 1956, but in the event the US government decided against Stansted's use for this purpose after all. The airfield was left with the longest runway in Britain at that time, but as the original lease to the USAF does not expire until 2041, Stansted remains officially a second-line NATO airfield to this day. By January 1954, the Civil Aviation Flying Unit fleet consisted of one Avro Anson, five Airspeed Consuls, five Doves, three Percival Princes and a solitary Chipmunk. From August 1955, the Doves gradually took over all instrument-rating flight testing from the Consuls. Until 1954, the main activity at Aviation Traders was the maintenance and dismantling for spares of Avro Yorks, but during that year they were awarded a contract to build fuselage sections for the Bristol 170 cargo aircraft, and also secured the necessary finance to buy up all the surviving Avro Tudors for conversion to Super Traders. In July 1955, Aviation Traders were also awarded a contract to overhaul the Sabre F.4 jets that had been on loan to the RAF from the US Air Force pending the delivery of the new Hawker Hunter fighter. The first Sabre arrived at Stansted on 28 July 1955, and ninety-nine examples were dealt with over the next two and a half years. Seventy-nine of these returned to the USA, but twenty had to be scrapped because of the non-availability of engines. Also, during 1955, Aviation Traders acquired 252 surplus Percival Prentice trainers from the RAF. These were flown into Stansted and Southend for conversion to civil touring aircraft. During the period April–July 1956, fifty-eight Prentices were ferried to Stansted, but the conversion idea failed to appeal to potential buyers and in the end only twenty-eight were eventually converted and sold. The rest were finally scrapped after being a part of the scenery at Stansted and Southend for some time.

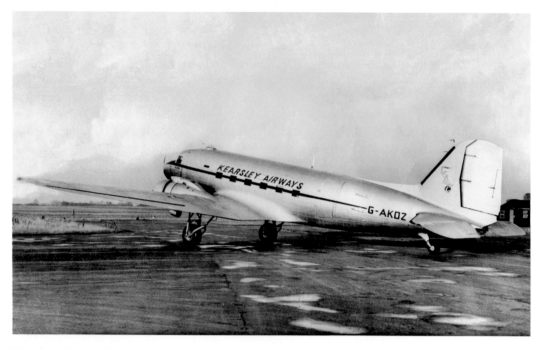

Kearsley Airways Dakota G-AKOZ. (Kearsley Airways)

The Nissen hut accommodation of Kearsley Airways at Stansted from 1950–1985. (Kearsley Airways)

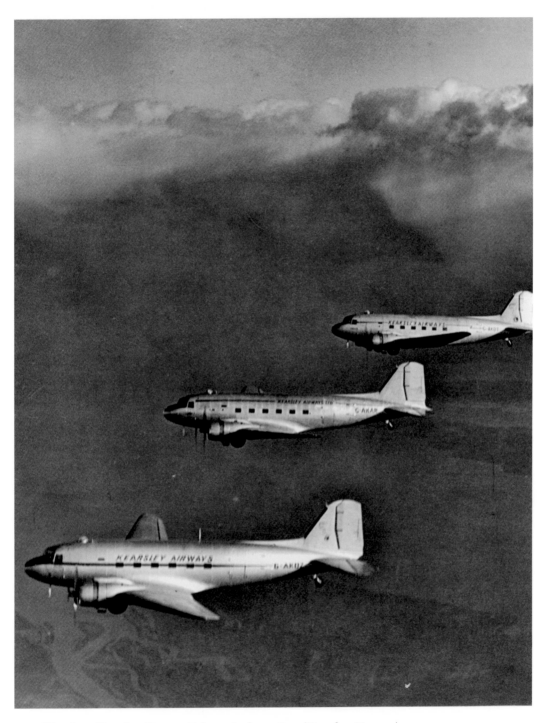

The three Kearsley Airways Dakotas in formation. (Kearsley Airways)

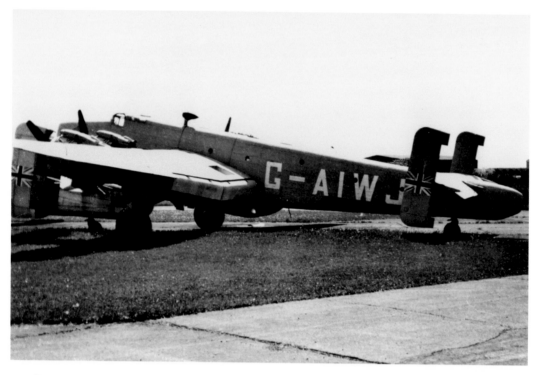

Handley Page Halifax G-AIWJ of London Aero & Motor Services at Stansted after withdrawal from service. From December 1950, this aircraft was used by the Ministry of Civil Aviation Fire School at Stansted. (Air-Britain)

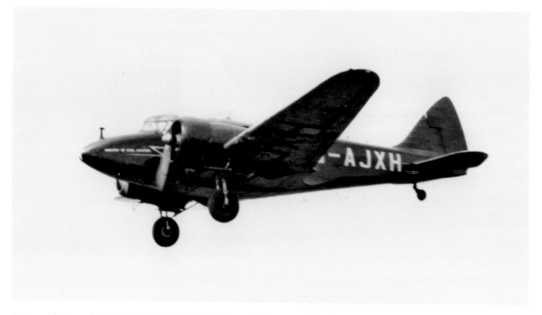

Airspeed Consul G-AJXH of the Civil Aviation Flying Unit landing. (Air-Britain)

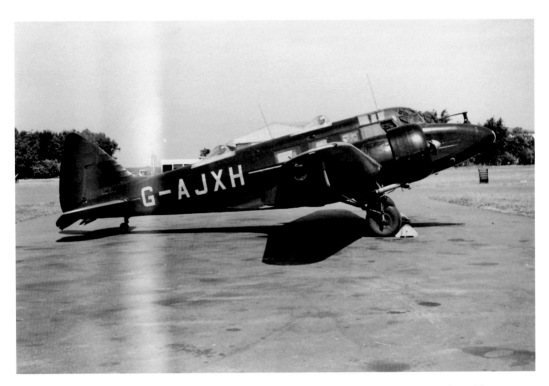

Airspeed Consul G-AJXH of the MCA Flying Unit at Stansted on 1 July 1952. (Gerald Lawrence via Tony Clarke)

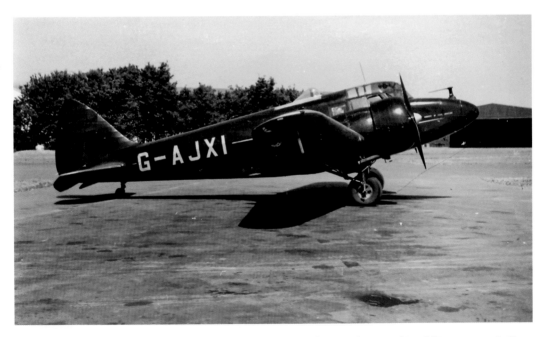

MCA Flying Unit Airspeed Consul G-AJXI at Stansted on 1 July 1952. (Gerald Lawrence via Tony Clarke)

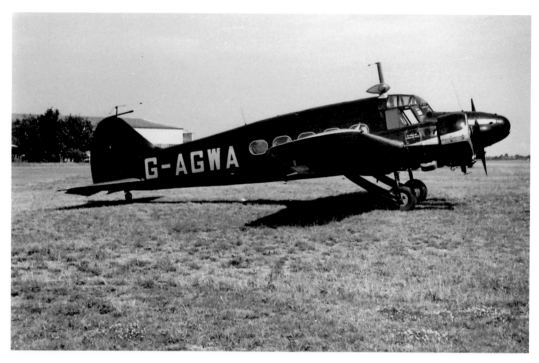

Avro Anson G-AGWA of the MCA Flying Unit at Stansted, 1 July 1952. (Gerald Lawrence via Tony Clarke)

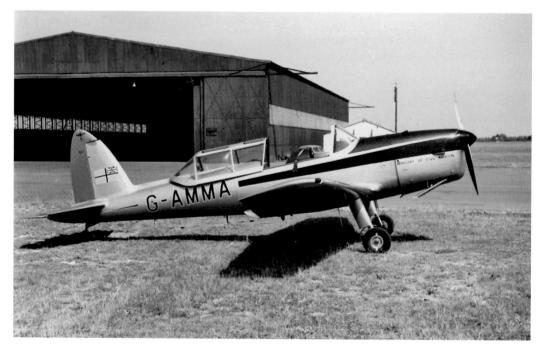

G-AMMA, one of the Chipmunks of the MCA Flying Unit, at Stansted on 1 July 1952. (Gerald Lawrence via Tony Clarke)

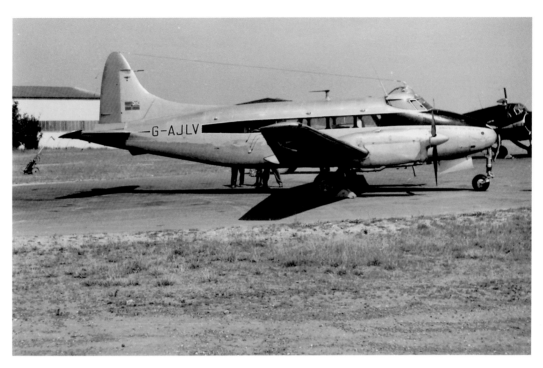

Early model De Havilland Dove G-AJLV of the MCA Flying Unit, seen at Stansted on 1 July 1952. (Gerald Lawrence via Tony Clarke)

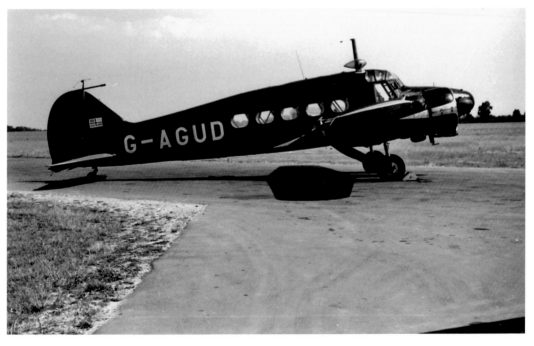

One of the MCA Flying Unit's Avro Ansons, G-AGUD, at Stansted on 1 July 1952. (Gerald Lawrence via Tony Clarke)

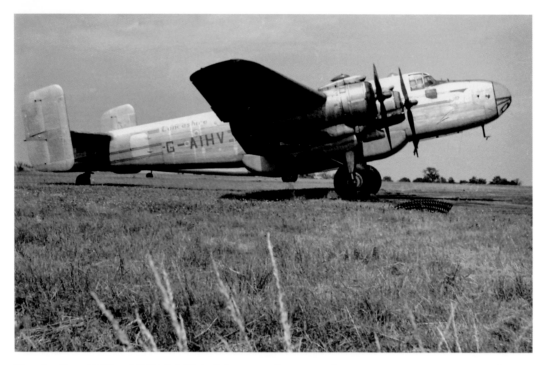

Handley Page Halifax C.VIII G-AIHV of the Lancashire Aircraft Corporation, at rest at Stansted on 1 July 1952. (Gerald Lawrence via Tony Clarke)

Avro Tudor 5 G-AKCB minus its port propellers at Stansted on 1 July 1952. (Gerald Lawrence via Tony Clarke)

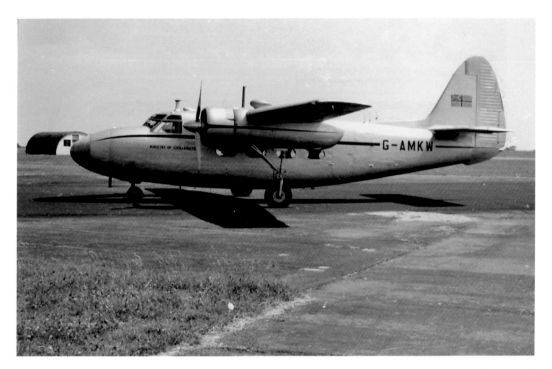

Percival Prince G-AMKW of the MCA Flying Unit seen at Stansted on 1 July 1952. This aircraft ended its days with the Stansted fire school. (Gerald Lawrence via Tony Clarke)

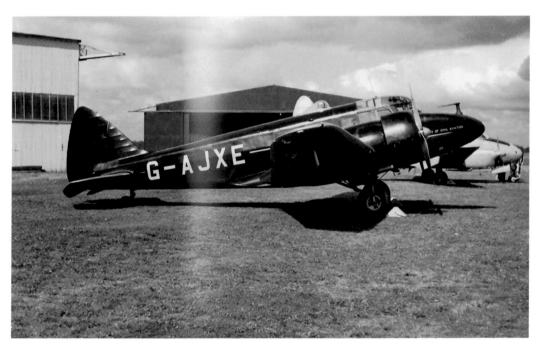

Ministry of Civil Aviation Airspeed Consul G-AJXE at Stansted on 13 September 1952. (Gerald Lawrence via Tony Clarke)

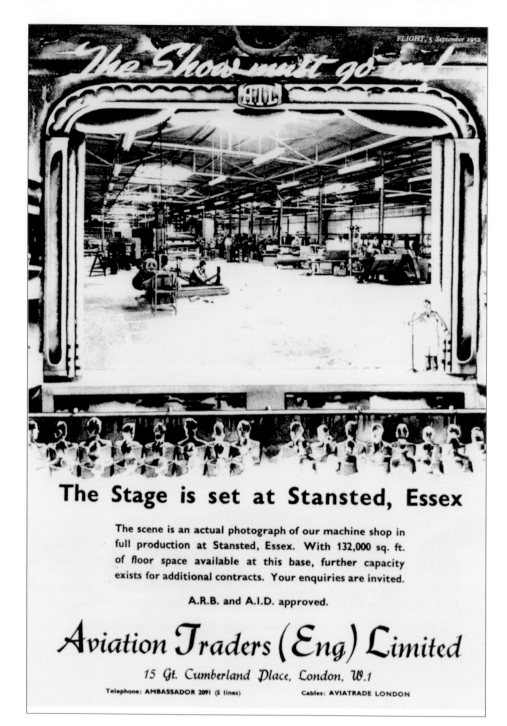

1952 press advertisement for Aviation Traders (Engineering), showing the interior of their machine shop at Stansted. (Via author)

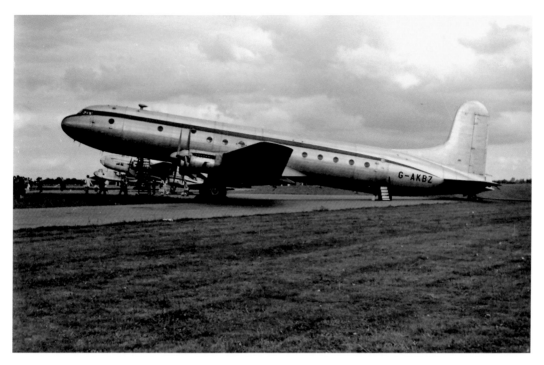

Avro Tudor 5 G-AKBZ in the static display at the Stansted airshow on 13 September 1952. Halifax and York aircraft in the background. (Gerald Lawrence via Tony Clarke)

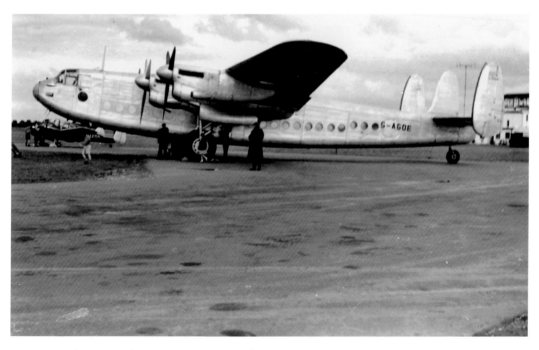

Lancashire Aircraft Corporation Avro York at Stansted on 13 September 1952. In the background is a Miles Gemini. (Gerald Lawrence via Tony Clarke)

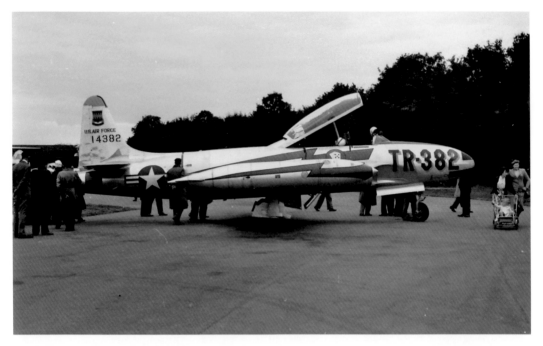

Wethersfield-based Lockheed T-33A 51-4382 at the Stansted airshow on 13 September 1952. (Gerald Lawrence via Tony Clarke)

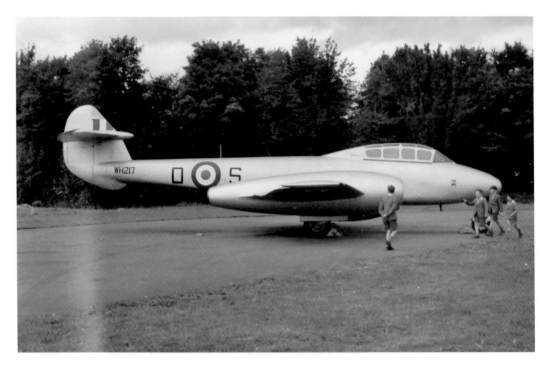

Gloster Meteor T.7 WH217 at the Stansted airshow on 13 September 1952. (Gerald Lawrence via Tony Clarke)

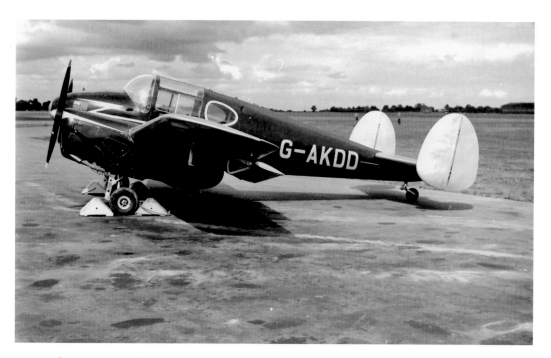

Mile Gemini G-AKDD of the MCA Flying Unit at Stansted on 13 September 1952. (Gerald Lawrence via Tony Clarke)

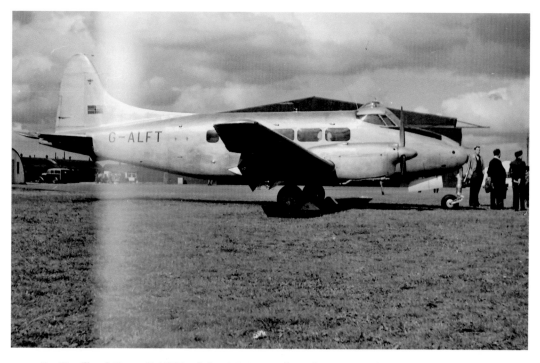

De Havilland Dove G-ALFT of the Ministry of Civil Aviation Flying Unit at Stansted on 13 September 1952. (Gerald Lawrence via Tony Clarke)

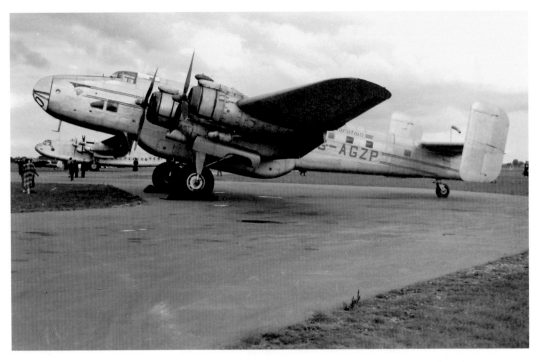

Handley Page Halifax G-AGZP of the Lancashire Aircraft Corporation at the Stansted airshow on 13 September 1952. Avro York in background. (Gerald Lawrence via Tony Clarke)

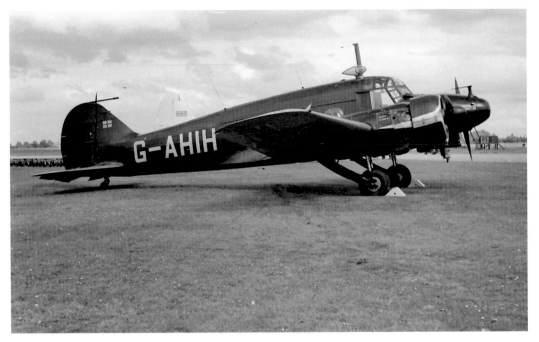

Avro Anson G-AHIH of the MCA Flying Unit at Stansted on 13 September 1952. (Gerald Lawrence via Tony Clarke)

Poster for the 1953 RAFA air display at Stansted. (Via author)

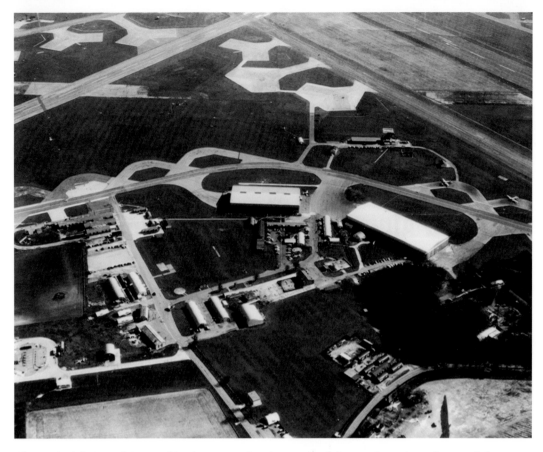

Above: Aerial view of Stansted in the 1950s, showing some of the wartime nissen huts and the hardstandings constructed for military use. (BAA)

Opposite above: Former RAF Avro York MW326 was purchased by Surrey Flying Services in 1953 for conversion to civil use as G-ANAC, but this was not carried out and it was broken up in 1955. Sections of it were incorporated into this shed at Stansted. (Brian Doherty)

Opposite below: De Havilland Dove G-ALFT of the Ministry of Civil Aviation outside the Helliwells hangar at Stansted on 26 September 1953. (via author)

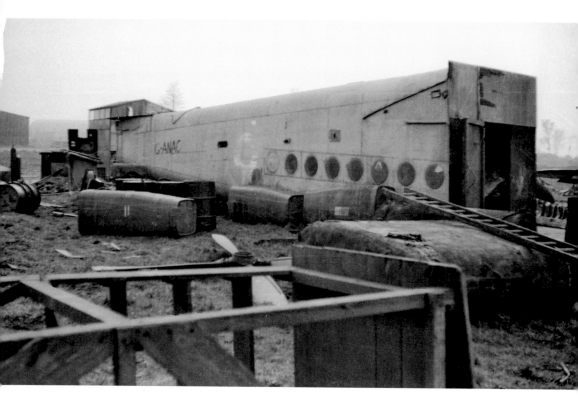

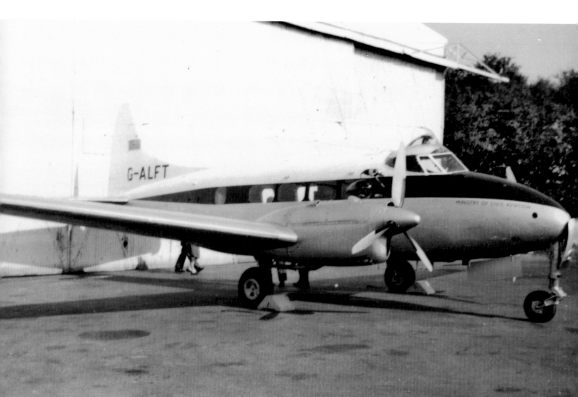

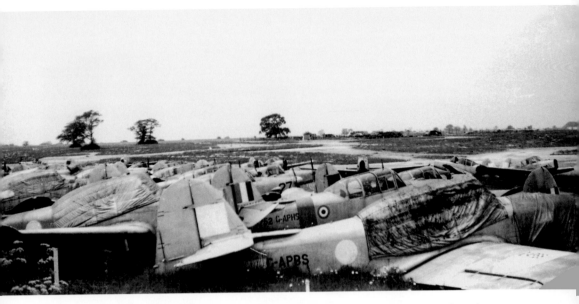

A view of part of the Percival Prentice 'graveyard' at Stansted in 1957. (Brian Doherty)

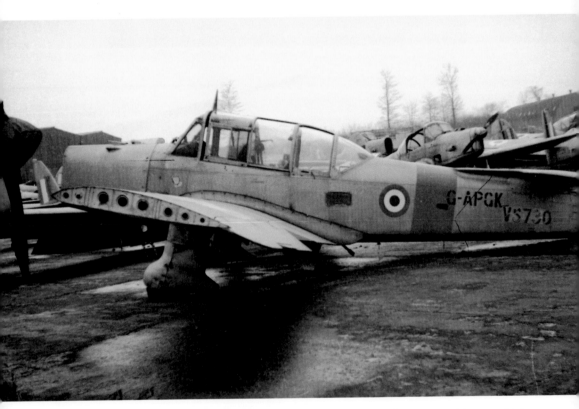

Percival Prentice G-APGK and compatriots in the Prentice 'graveyard' at Stansted in 1957. (Brian Doherty)

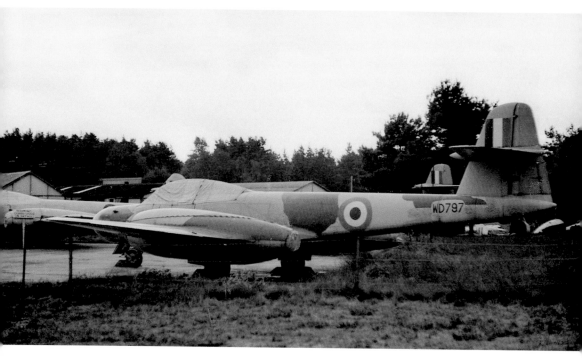

Gloster Meteor WD797 at Stansted in 1957. (Brian Doherty)

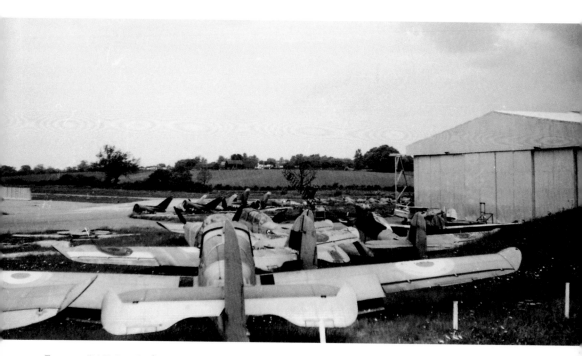

Former RAF Percival Prentices at Aviation Traders in 1956–57. Also visible are the tails of scrapped former RAF F-86 Sabres. (Brian Doherty)

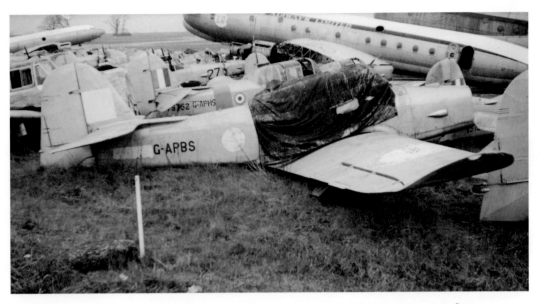

Percival Prentices awaiting scrapping at Aviation Traders in 1957. In the background, two Avro Tudors await the same fate. (Brian Doherty)

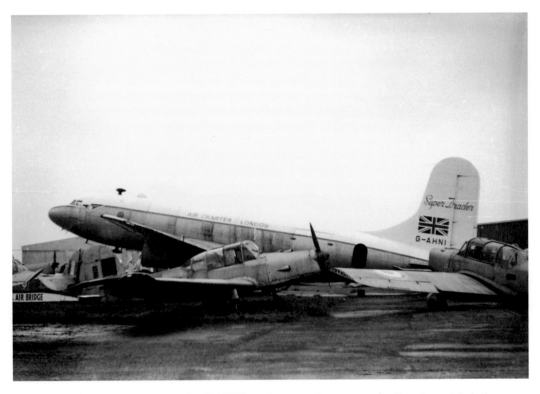

Former Air Charter Avro Supertrader G-AHNI awaits scrapping among the Prentices at Aviation Traders in 1957. (Brian Doherty)

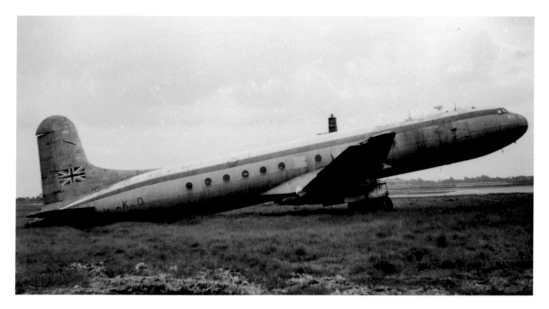

Avro Tudor G-AKCC of William Dempster ends its days among the Prentices at Aviation Traders in 1957. (Brian Doherty)

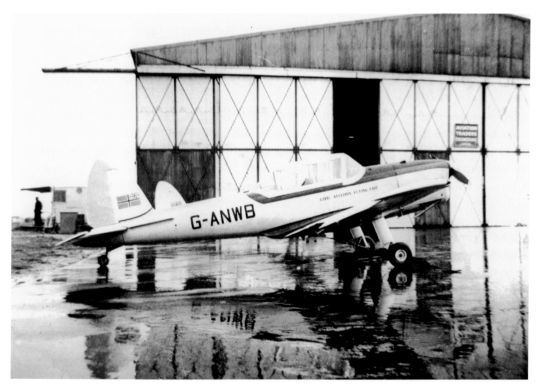

Civil Aviation Flying Unit Chipmunk G-ANWB outside the Aviation Traders hangar on 30 July 1959. (Barry Abraham)

The Development of Trooping Flights

From 1 August 1955, Skyways of London began operation of a twelve-month Air Ministry contract valued at £500,000 for the carriage of more than 12,000 troops and their families from Stansted to Nicosia via Malta in their new Hermes aircraft. Air Charter Ltd were also expanding their operations and, from August 1954, they operated a daily Avro York trooping flight from Stansted to Fayid in the Egyptian Canal Zone. On 6 September 1956, one of their Avro Supertrader aircraft landed back at Stansted after flying 2,350 miles non-stop from Gander, Newfoundland, on the last leg of a ship's crew charter to Jacksonville in Florida and onwards to New York. In April 1956, an Avro York of Scottish Airlines was about to operate a trooping service to Habbaniyah in Iraq with forty-nine RAF personnel and families and five crew. The main runway at Stansted was closed for maintenance and so the parallel taxiway was used for the take off on the first leg to Malta. During the take-off run the aircraft swung violently to the right and the undercarriage collapsed. Two passengers were killed in the accident, and Scottish Airlines were to lose another York aircraft on 23 December 1957. G-AMUN was inbound to Stansted on a cargo flight from Malta and had already made two aborted landing attempts. On the third approach the aircraft collided with a tree some three-quarters of a mile short of the runway and crashed in flames, killing all four occupants. By early 1958, Scottish Airlines' trooping contracts had come to an end. Some ad hoc charters were still operated from Stansted but in August 1958 the remaining aircraft were sold and flying ceased. During April/May 1957 Skyways of London was operating Hermes trooping flights to Bangkok in association with another Hermes operator, Airwork Ltd. Passengers assembled at the Army-operated Assembly Centre at 209 Harrow Road in London for transport to Stansted and the journey to Bangkok via Brindisi, Ankara, Baghdad, Karachi (where a night stop was made), Delhi and Calcutta. During 1958, Skyways was also operating a scheduled freight service for livestock and attendants from Stansted to Beauvais in France. Avro York freighters were used, fitted out with horse boxes for six or seven horses plus their grooms. In April of that year, however, the airline suffered a setback when one of its Hermes aircraft was lost while on a local

training flight from Stansted. The aircraft's elevator mechanism became jammed and it lost height in a series of dives and climbs until it struck the ground at Meesden Green and caught fire. All three occupants were killed. By 1959, all of Skyways' services had been transferred to Heathrow and Stansted was only used for maintenance and crew training, including that for the four Constellation aircraft the airline had obtained on lease-purchase from BOAC in June 1959. On 1 September 1962, Skyways was taken over by Euravia. On 1 October 1958, one of Air Charter Ltd's newly-delivered Britannia srs 300 turbo-props made the first of a series of trooping runs from Stansted to Christmas Island in the Pacific.

Up to 124 passengers were carried on each flight, and on 5 February 1959 a Britannia left Stansted for Adelaide and Sydney with 100 service personnel. From Australia the aircraft flew on to Christmas Island to pick up 112 passengers before returning to the UK via San Francisco and Montreal. It arrived back at Stansted on 12 February, having completed the round-the-world trip in a total flying time of 72 hours 30 minutes. The delivery of the second Britannia enabled the Avro Supertraders to be retired, and at 1441 on 16 June 1959 G-AHNI touched down at Stansted from Lisbon, completing the last-ever revenue service by the type. In 1960, Air Charter Ltd was merged into British United Airways, who continued to use Britannias on trooping flights from Stansted, with up to nine examples being based there for services to Hong Kong, Singapore, Nairobi, Aden, Cyprus, Malta and West Germany. The last British United trooping flight out of Stansted arrived back there on the night of 1 October 1964. The operations were the transferred to Gatwick, leaving Stansted with no resident airline operator.

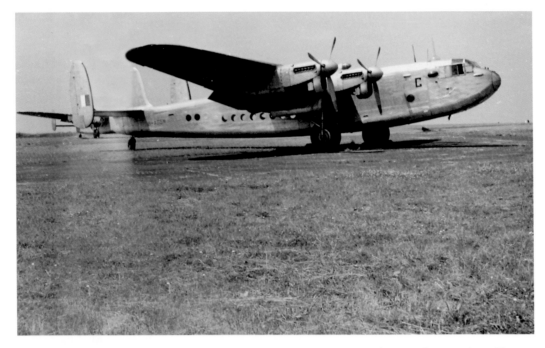

Avro York G-AGSM of the Lancashire Aircraft Corporation at Stansted on 1 July 1952. (Gerald Lawrence via Tony Clarke)

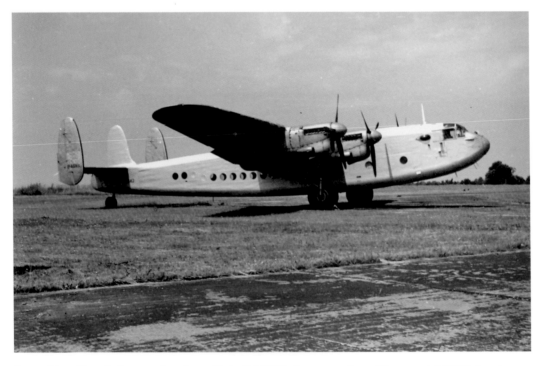

Lancashire Aircraft Corporation Avro York G-AGNX also wears its military serial WW582 at Stansted on 1 July 1952. (Gerald Lawrence via Tony Clarke)

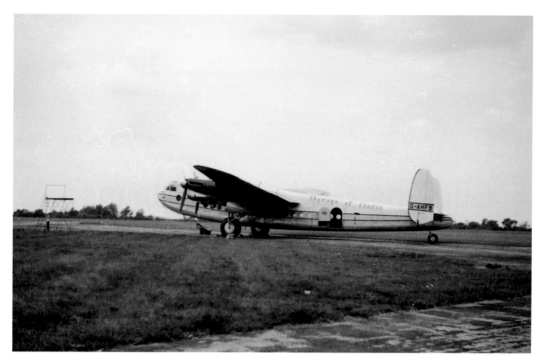

Skyways Avro York G-AHFB at Stansted in 1957. (Brian Doherty)

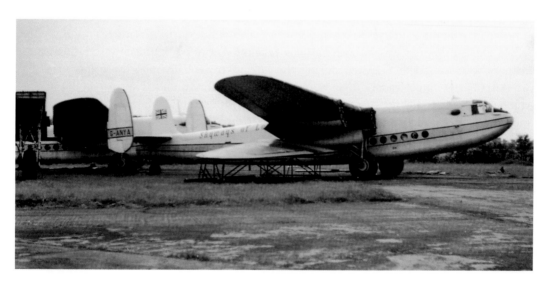

Skyways Avro York G-ANYA at Stansted after withdrawal from service in August 1959. (Brian Doherty)

Clinging On by Any Means

The opening of the new terminal facilities at Gatwick in 1958 impacted on Stansted's aircraft movements, and passenger numbers dipped to around the 20,000 mark, including trooping flights. Stansted's rural location and scarcity of aircraft movements led to visits from two early jet airliners during 1958. An Aeroflot TU-104 carrying a party from the Moscow Arts Theatre to London was obliged to land at Stansted instead of Heathrow because the capital's main airport was not accepting that aircraft type on account of its unacceptably high noise levels. In September of that year Pan American World Airways brought an early model Boeing 707 to London for noise-acceptance tests. The aircraft landed at Heathrow on the inbound leg but then positioned to Stansted in order to attempt a non-stop crossing on the westbound journey. With twenty-nine people aboard the 707 was airborne after a take-off run of 8,500ft. Many redundant airliners were stored at Stansted during the late 1950s, and in 1959 these included two Air Charter Supertraders, five Skyways Hermes aircraft, and five former BOAC Argonauts. Retired airliners were also used by the Ministry of Aviation Fire Service Training Centre, which transferred to Stansted from Pengham Moors airfield near Cardiff in 1960. The centre occupied an area close to the site of the present-day cargo area and well away from the passenger terminal of the time. It used a former wartime USAAF chapel as its main lecture hall. It relocated from Stansted to Tees-Side airport in August 1981. BEA and BOAC used Stansted for crew training sorties, and BEA deployed Viscount, Vanguard, Argosy, Comet 4B and Trident aircraft there for this purpose until transferring this activity to Shannon and Malta. In July 1961, Aviation Traders Engineering relocated the final assembly work on its Carvair car-ferry conversion of the Douglas DC-4 from Southend to Stansted. The first Stansted-assembled Carvair flew in 1962, and eighteen conversions were completed at the airfield. During 1961/62, an Air Ministry Type T.2 hangar at the airport was enlarged by Taylor Woodrow Construction to enable Aviation Traders to accommodate two Britannia aircraft within it nose to nose. The first use of Stansted by passenger jet aircraft on revenue services occurred in 1961. Following a proving flight to New York's Idlewild Airport on 21 March, KLM operated a series of around twenty-five Douglas DC-8 charters on the route during April–September. The airline had been prevented from using Heathrow for the flights by

noise restrictions at peak landing times. These charters added 2,500 or so passengers to that year's total, and further charter flights were to be operated to destinations such as Los Angeles and Calgary by Capitol Airways and Canadian Pacific Air Lines, although these airlines transferred their operations to the better-equipped Gatwick in 1965. At that time, Stansted was still utilising wartime Nissen huts for passenger handling, and passengers on flights diverted there sometimes had to remain on board their aircraft for some time as the terminal facilities could not cope with the extra workload. On 3 August 1962, BOAC Comet 4 G-APDM on a training flight suffered an undercarriage collapse upon landing at Stansted, but the damage was not severe.

On 1 May 1964, Stansted officially became London (Stansted) Airport, and during that year Southend-based Channel Airways, anticipating Stansted's eventual selection as London's third airport, applied to the Air Transport Licencing Board for a network of scheduled services to destinations including Basle, Biarritz, Palma, Lisbon, Barcelona, Valencia, Luxembourg, Rome, Naples, Milan, Munich, Innsbruck, Ajaccio and Alghero, with the aircraft types to be used including Bristol Britannia, Handley Page Herald and HS 748 turbo-props and Comet 4 and One Eleven jets. Channel also sought permission to use Stansted as an alternative terminal for the cross-Channel and Channel Island scheduled services it was operating from Southend. During 1964, Aviation Traders Engineering was experiencing a downturn in its workload, and on 23 July 160 staff were made redundant. A spokesman for the company said that, 'It is no longer economical to continue operations at Stansted.' Despite this, the base at Stansted remained open, and business eventually picked up for the company and for the airport. At the end of November 1965, Lloyd International Airways moved in from Gatwick with its fleet of two Britannias and a DC-4, and although less than 4,000 passengers passed through in the financial year 1965/66, and KLM was the only foreign airline using the airport on a regular basis, aircraft movements slowly increased. The German charter airlines LTU and Condor began flying in, and in May 1966 the passenger handling at the airport was taken over from British United Airways by Avia. A surprise visitor on 14 April 1966 was Aeroflot TU-104A CCCP-42456, which diverted in from Heathrow with technical problems and ended up staying for three days.

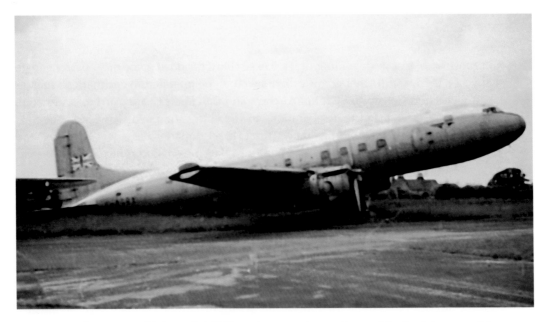

Former Air Charter Avro Tudor 2 G-AGRY awaits scrapping at Stansted in the late 1950s. (Tom Singfield)

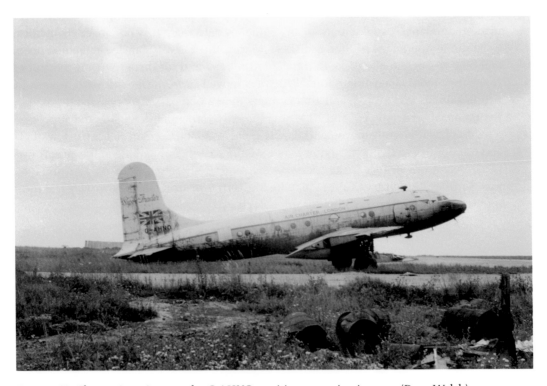

Former Air Charter Avro Supertrader G-AHNO awaiting scrapping in 1959. (Dave Welch)

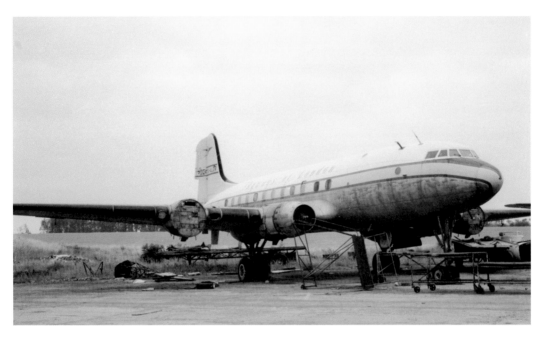

Handley Page Hermes G-ALDR of Skyways of London awaits scrapping in 1959. (Dave Welch)

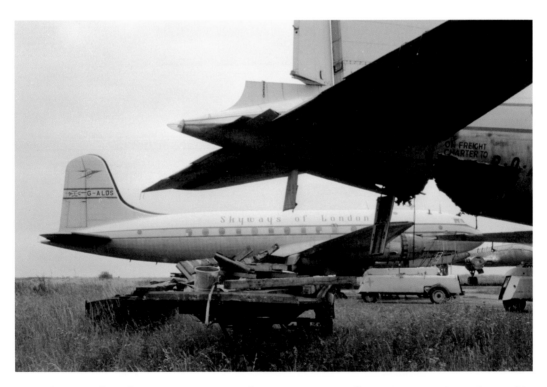

Skyways of London Hermes G-ALDS with two compatriots, all awaiting scrapping at Stansted in 1959. (Dave Welch)

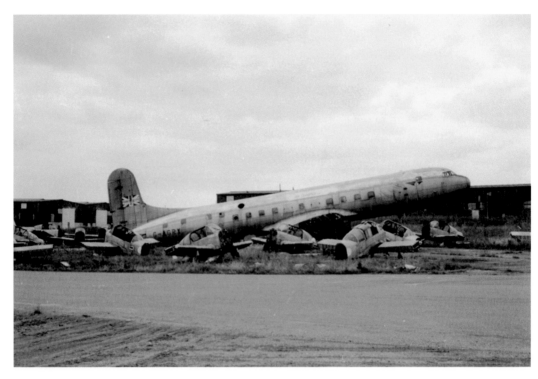

The fuselage of Avro Tudor 2 G-AGRY looms above dismembered Percival Prentices at the Aviation Traders 'graveyard' in 1959. (Dave Welch)

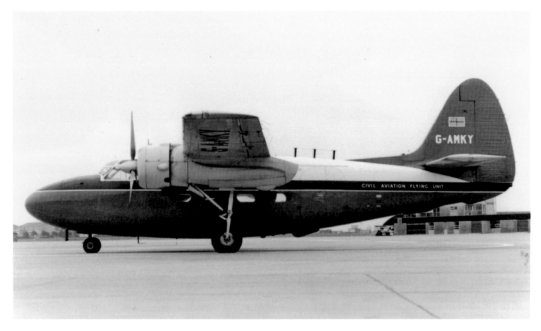

Percival Prince 6B G-AMKY of the Civil Aviation Flying Unit at Stansted. (Via author)

The CAFU photographic building in a wooded corner of Stansted, *c.* 1967, with a period car and motorcycle. (Tony Doyle)

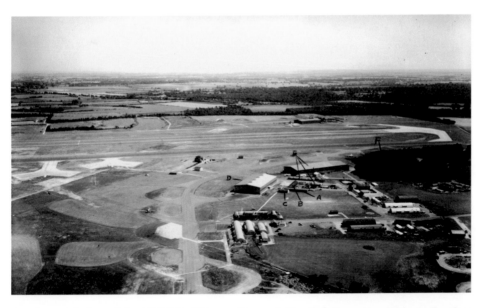

A 1967 aerial view of the CAFU facilities at Stansted. Key to letters: A – Aircrew; B – Ops and Admin; C – Flight Inspection Planning and Evaluation; D – Telcoms workshops (behind hangar); E – CAFU hangar and maintenance buildings; F – Photographic section and drawing office (in woods). (Tony Doyle)

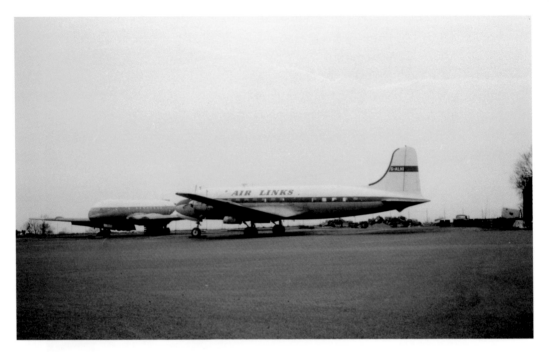

Former Air Links Canadair Argonaut G-ALHI and a derelict Comet at the Fire School in the late 1960s. (Dave Welch)

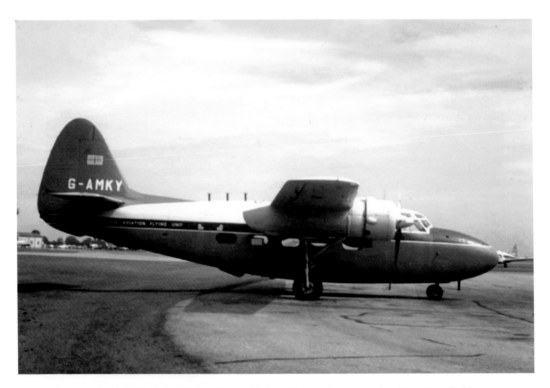

Percival Prince G-AMKY of the Civil Aviation Flying Unit in August 1969. (Tom Singfield)

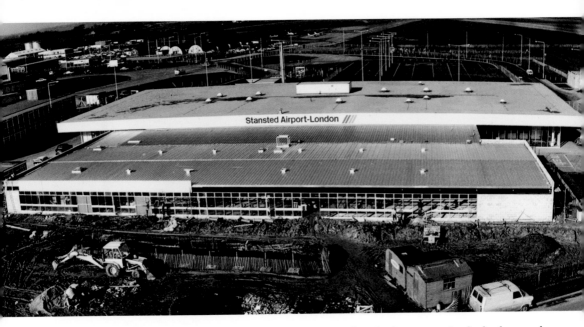

Work in progress on the extension to the interim terminal in the late 1970s. In the background some of the original Nissen huts still survive. (BAA)

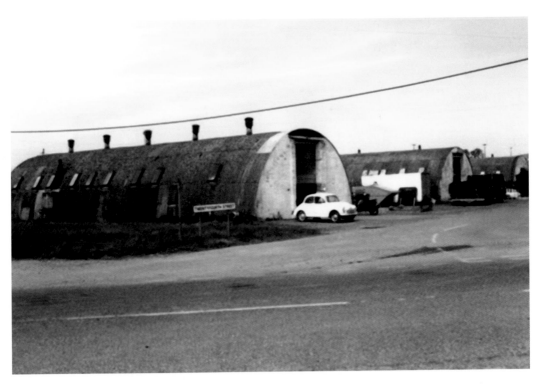

Some of the original wartime Nissen huts, still in existence in the 1980s. (Paul Francis)

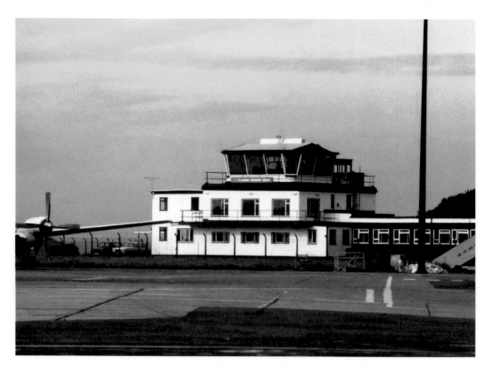

The old control tower at Stansted, not long before closure. (Paul Francis)

Two of the original wartime buildings still in use in the 1980s. (Paul Francis)

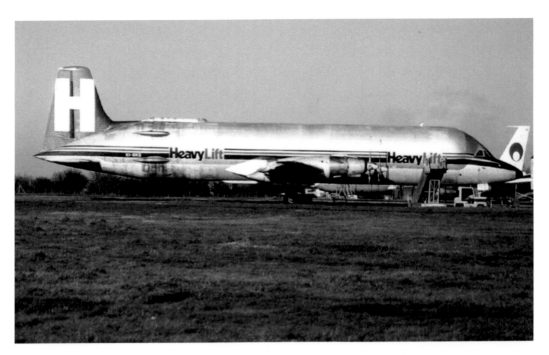

The unique Conroy CL-44-0 freighter of Heavylift at the Aviation Traders premises. (George Pennick)

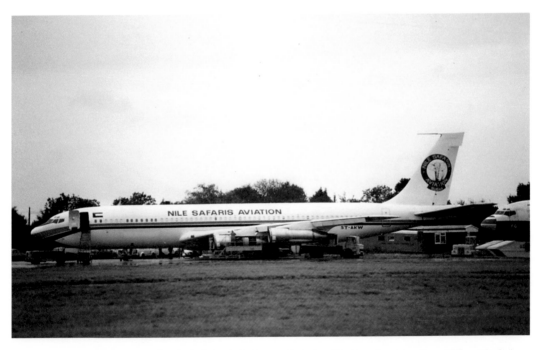

Boeing 707 ST-AKW of Nile Safaris Aviation at Aviation Traders for attention. (Allen Clarke)

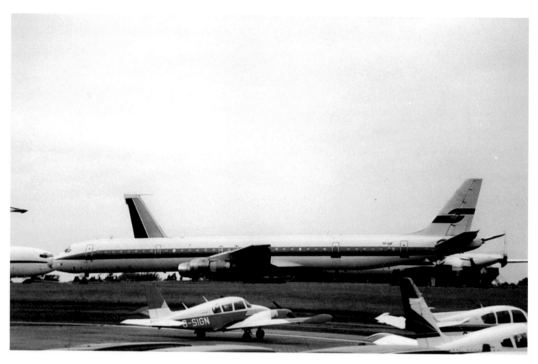

A crowded maintenance area scene, with DC-8 TF-IUF prominent. (Allen Clarke)

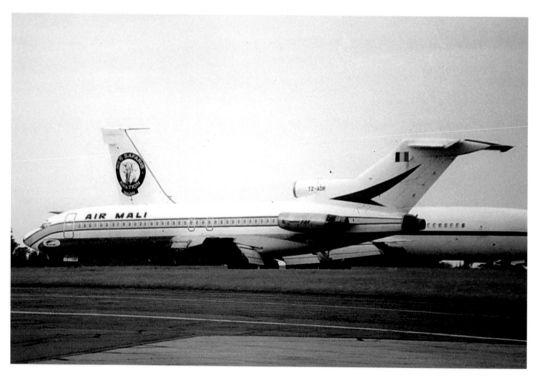

Air Mali Boeing 727 TZ-ADA in for maintenance at Aviation Traders. (Allen Clarke)

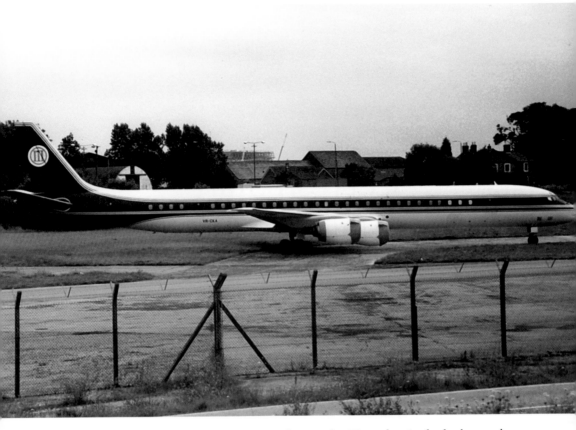

Executive, stretched DC-8 VR-CKA at Stansted. Note the Nissen hut in the background. (Allen Clarke)

A Fresh Start

On 1 April 1966, the British Airports Authority took over control of Heathrow, Gatwick, Stansted and Prestwick airports from the Ministry of Aviation. The BAA had been set up under the Airports Authority Act 1965 'to provide efficient, courteous, attractive and profitable Gateways to Britain, worthy of the nation as a whole.' BAA Chairman Peter Masefield toured the airports in a chartered Channel Airways HS 748 to speak to the staff and to relay a message from the Minister of Aviation thanking them for all they had accomplished under Ministry employment. At Stansted, he was presented by the airport manager with a piece of one of the windows of the Viscount aircraft in which he had taken part in the 1953 London-Christchurch NZ Air Race, the aircraft eventually ending its days on the Stansted fire dump.

On 12 May 1967, a government White Paper entitled 'The Third London Airport' was published. This came out in favour of Stansted being developed for this purpose over nine other possible sites:

Gunfleet Sands (in the North Sea, 5 miles off Clacton).
Dengie Flats, Foulness, Cliffe Marshes, and the Isle of Sheppey (all on the Thames Estuary).
Plumstead Marshes (south-east of London).
Padworth (about 8 miles south-west of Reading).
Thurleigh Airfield (about 8 miles north of Bedford).
Silverstone (about 14 miles south-south-west of Northampton).

The reasons for rejecting these other candidates were varied. For example, the use of Dengie Flats, Foulness, Cliffe or Sheppey would mean the closure of the firing range at Shoeburyness. The selection of Padworth would result in the closure of the Atomic Weapons Research Establishment at Aldermaston and the end of flying activities at Farnborough, and the use of Silverstone would render eight major RAF and USAF airfields effectively unusable for military flying. At a press conference the President of the Board of Trade, Douglas Jay, said that development of Stansted would begin immediately. The BAA already had plans for an interim terminal building to replace

the existing facilities until the definitive design was ready for use. Work on the interim terminal was to start in 1968, for completion by 1970. At that time, construction of a second runway, parallel to and to the south of the existing main runway, would be started. The initial length of the new runway would be 12,000ft, and it was to be completed in 1974. There was also the possibility of lengthening the existing main runway to 13,000ft. Two further parallel runways would later be added, staggered laterally from the first pair. Some 2,000 acres of land would need to be acquired for the second runway, and some fifty houses and 'a few' farm buildings would have to be demolished. Stansted would primarily serve as the designated long-haul alternative to Heathrow, although this would not inhibit the development of short- and medium-haul services as well. The M11 motorway would have neared Stansted 'by the early 1970s'. With regard to rail links the White Paper said that by the provision of a spur between the airport and the main line at Bishop's Stortford, and by other minor works, Stansted could be brought (although admittedly by a circuitous route by way of Kings Cross and Brixton) within an hour's journey by train from Victoria, and in the same way it could be made accessible to Kings Cross itself in less than an hour. The cost of the proposal was to be about £47 million in total. In June 1967, Peter Masefield of the BAA said that once Stansted was fully developed sometime in the early 1980s and had two pairs of parallel runways it should be capable of handling 43 per cent of a projected total of 250 aircraft movements each hour at Heathrow, Gatwick and Stansted combined. He thought that the airlines using Stansted would for the most part be those which did not have major engineering bases at Gatwick or Heathrow. At least one major British airline apart from BOAC, BEA and British United Airways could be expected to develop a radial pattern of services from Stansted, with reciprocal operations by foreign carriers. The current 877 acres the airport covered would have to be increased to around 5,000 acres, and the population of the neighbouring towns of Bishops Stortford, Saffron Walden, Great Dunmow, Harlow and Sawbridgeworth would be boosted by around 45 per cent by the influx of an estimated 20,000 airport workers and dependants. Although the go-ahead had been given for the £47 million investment, Essex County Council issued a writ to halt the development and in October 1967 the government was forced to slow down the timetable and subsequently realign the proposed runway layout and alter the flight paths to minimise aircraft noise around the surrounding towns and villages. In response to the local opposition it was announced in February 1968 that a new commission on London's third airport, to be known as the Roskill Commission, was to be set up to re-examine the viability of the other sites.

By June 1967, the Civil Aviation Flying Unit fleet included an HS 125 executive jet, and in addition to pilot proficiency checks the Unit also carried out examiner training, VIP transportation, and investigations into surveillance radar problems. In the middle of that year the Ford Motor Company, with its UK base at nearby Brentwood in Essex, set up an Air Transportation Department at Stansted under Captain John Wilson to provide in-house transport for the company's corporate and technical staff. A maintenance contract was set up with Aviation Traders and a single engineer was taken on to look

after the department's first aircraft, Grumman Gulfstream 1 G-ASXT, which Captain Wilson had previously flown for Shell. A former Scottish Airways Type T2 hangar was taken over and a Nissen hut was used as an office. At 0805 on 14 August 1967, G-ASXT took off for Cologne on the first 'Fordair' service from Stansted. With the acquisition of a second Gulfstream 1 in 1969 two more engineers were taken on and the contract with Aviation Traders was terminated. During the 1970s, Gulfstream 2 and HS 125 executive jets and One-Eleven airliners were to join the fleet, with the principal destinations for the corporate flights being Valencia, Liverpool, Cologne and Marseilles. On 4 December 1967, BEA Argosy G-ASXP was engaged on crew training sorties at Stansted. During one take-off a failure of the No. 4 engine was simulated, but control of the aircraft was lost and it cartwheeled on its starboard wing and caught fire. The three occupants survived, but the aircraft was a write-off.

In 1968, Essex County Council granted planning permission for the BAA to construct its interim terminal building at Stansted. In the meantime some £20,000 was to be spent on extending and improving the existing terminal and car park, the work to commence immediately for completion by 1 April that year. The total area of the terminal building was to be increased from 13,500 sq.ft to just over 20,000 sq.ft, to incorporate a new passenger lounge, customs area and refreshment facilities. The passenger flow for the period April–September 1968 was expected to reach 120,000, mainly due to the expanded activities of Channel Airways. The airline had been experiencing problems with the operation of its new One-Eleven jets out of its Southend base because of runway length limitations and complaints about aircraft noise from nearby residents and had transferred its jet flight programme to Stansted. A Viscount turbo-prop service to Jersey was also introduced in May 1968, and by the end of the year Channel Airways was occupying a newly built two-storey operations and administration building at Stansted, which it named Channel Airways House. Throughout the summer a programme of inclusive-tour flights to many destinations was operated by One-Eleven and Trident jets. Up to 100 flights each week were operated, bringing about a 300 per cent increase in passenger traffic at Stansted. During the year approval was given for night operations, and in April Servisair took over passenger handling at Stansted, following that company's appointment as the BAA's first official handling agent. Initially, Servisair based just three employees at Stansted, working out of a small wooden hut on the site of the airport's first police station. The £198,000 contract for the construction of the interim terminal building was awarded to local builders J. A. Elliott Ltd, and work commenced in September 1968. Early in the summer of 1968 Stansted had gained another resident airline when the all-cargo operator Trans-Meridian Airways transferred its operating base from Cambridge airport. Initially, Douglas DC-7Fs were used, but from December 1968 the airline began to replace these with Canadair CL-44 turbo-props, and introduced fast cargo services to the Far East.

In 1969, the Roskill Commission produced a shortlist of four possible sites for London's third airport. These sites were:

Cublington, to the west of Leighton Buzzard.

The Royal Aircraft Establishment airfield at Bedford.

Nuthampstead, a wartime USAAF base to the south of Royston, Herts.

An offshore site at Foulness(Maplin), to the north-east of Southend.

Stansted was not even short-listed because it was felt that Nuthampstead offered greater advantages from the air traffic control and aircraft noise points of view. However, all four of the above proposals also met with opposition from local action groups. In the event, the Commission's recommendation of Cublington as first choice was rejected in favour of Foulness (Maplin), but Stansted still remained an outsider.

In January 1969, Channel Airways inaugurated its 'Scottish Flyer' multi-stop service linking numerous airports in England to Scotland on a twice-daily basis. From Stansted flights to East Midlands airport connected with services to Leeds/Bradford, Tees-Side, Newcastle, Edinburgh and Aberdeen. The service was not a financial success though, and it was terminated after ten months of operations had incurred losses of £160,000. Compensation came in April 1969, however, when Channel Airways announced that it had been awarded a £5 million contract for the operation of the entire tour flight programme of Lyons Tours for the period 1970–1972. Five Comet jets were acquired from BEA and Olympic Airways to operate the flights, with the first aircraft arriving at Stansted on 26 January 1970. The new interim terminal building adjacent to the control tower was officially opened on 30 May 1969 and, perhaps inevitably, the first passengers to use the facilities were on a Channel Airways service to Jersey on 4 June. The original Nissen huts remained in use as overflow accommodation in the event of delayed flights, et cetera., and were not demolished until the summer of 1996. During 1971, delayed passengers were provided with meals in them by Airport Catering Services Ltd. who charged the airlines 10s 6d for a hot breakfast, 10s for a continental breakfast, and £1 1s 0d to £1 2s 0d for lunch or dinner. In June 1971, work began on extensions to the interim terminal to provide an additional 13,500 sq.ft of floor capacity. This was sorely needed as, during 1970, the US charter airline Overseas National Airlines expressed its dis-satisfaction with the facilities provided for its transatlantic DC-8 passengers, and erected at its own expense a 300 sq.ft marquee at the airport to give them more space. During 1970, the Danish airline Sterling Airways operated Caravelle jet flights to Copenhagen on Tuesdays and to Paris on Sundays, and also used piston-engined DC-6B aircraft on services from Billund. A dock workers' strike for several weeks in July and August 1970 brought many cargo charter flights into Stansted, and in April of that year Lloyd International Airways began using its new fleet of 189-seat Boeing 707s on passenger charters to the Far East, the USA and Canada. Turbo-prop Britannias were still used for scheduled cargo services to Hong Kong, and in July 1970 the airline opened new offices at Stansted. However, financial problems eventually brought down the company and Lloyd International ceased operating and appointed a Receiver on 16 June 1972. During 1970, 519,534 passengers passed through Stansted, and the airport made a profit of £75,000 for the financial year 1970/71.

The varied fortunes of Aviation Traders improved slightly in 1970 when the company took on the maintenance of the Boeing 707s of British Midland Airways and other airlines as well as work on Britannias, Vanguards and Canadair CL-44s of various operators. During the year, Trans-Meridian Airways began to trade as Transmeridian Air Cargo and took on the lease of the one-off Conroy CL-44 for the carriage of outsize loads. The Civil Aviation Flying Unit took delivery of two HS 748 turbo-props as replacements for the Percival Princes and President on calibration work. The fleet of Doves was put up for sale from 1971 onwards, and on 26 March 1971 the Unit finally moved from its temporary accommodation at Stansted into new purpose-built premises at the airport. On 21 September 1970, Channel Airways announced that it had applied to the Canadian and US authorities for permits to operate North Atlantic affinity-group charters with a fleet of Boeing 707s. However, the summer of 1971 was not a good season for the airline, which struggled with technical delays and spares shortages. Trident G-AVYE sat idle at Stansted as its engines had been cannibalised to keep its sister ship operating charters out of Berlin, and the Tridents were soon sold to BEA. In January 1972, following the refusal on appeal of an application for a scheduled service to Glasgow, Channel announced that it was to close its engineering facilities at Stansted and concentrate this activity at Southend. Maintenance of the Comet fleet was to be contracted out to Aviation Traders at Stansted, and only four examples were to be operated in 1972. The Stansted–Jersey services were dropped, but the airline insisted that it had no plans to pull out of Stansted entirely. However, on 1 February 1972, a Receiver was appointed and all flying ceased at the end of that month. The giant Boeing 747 made its first visit to Stansted on 8 February 1971 when BOAC example G-AWNB arrived on a crew-training sortie. During the year a new dedicated cargo area came into use on the eastern side of the airfield. During 1971, 493,000 passengers passed through Stansted, but in 1972 aircraft movements were down 20 per cent on the previous year, and in 1973 the passenger total for the year was down to 176,000, illustrating the impact made by the failure of Channel Airways.

From September 1972 onwards many charter flights brought into Stansted large numbers of political refugees fleeing from the rule of President Idi Amin in Uganda. 18,000 people arrived aboard aircraft of Donaldson International, British Caledonian Airways and BOAC, and to handle them the former Channel Airways building was converted into a reception area with medical and refreshment facilities. During 1973, many improvements were made to the airside areas at the airport, including the strengthening of the main apron areas and the provision of floodlighting. Servisair took delivery of a set of Boeing 747 steps and a tug powerful enough to tow wide-bodied jets, and in May 1973 Court Line began using Stansted for training flights with their new Lockheed Tri-Stars. In January 1973, Aviation Traders reopened Hangar 1 for overhauls, the first customer being an HS 748 of the Civil Aviation Flying Unit. By 1975, the Unit was responsible for the calibration and checking of almost sixty Instrument Landing Systems installations on a three-monthly basis. On 7 January 1975, a lone hijacker seized control of a British Airways One-Eleven jet, which was enroute from Manchester. This

was the first hijacking to take place in the UK, and the hijacker at first demanded to be flown to Paris. He was persuaded to allow the aircraft to land at Heathrow first, and the passengers were allowed to disembark there in exchange for £100,000 and a parachute. The aircraft then took off and flew to Stansted, where an attempt had been made to disguise the airport as Orly airport in Paris. The One-Eleven landed at 2325 and was taxied to the Fordair hangar, where the hijacker tried to escape but was captured. Upon being searched, he was found to be armed with only a toy pistol.

During 1975, 238,000 passengers passed through Stansted, with over one fifth of them being carried aboard Fordair flights. There were still no scheduled passenger airlines based at Stansted, although in May of that year Transmeridian Air Cargo inaugurated weekly Canadair CL-44 services to Kano and Lagos, supplementing its existing regular flights to Cairo and Asmara. On the passenger side, Stansted still handled only thirty-two regular services each week including a Jersey European Airways schedule to Jersey via Shoreham, but work still went ahead at the end of 1976 on a 6,456 sq.ft extension to the interim terminal building to provide a better baggage reclaim area and a covered walkway from the terminal to the aircraft stands. Plans for a completely new permanent terminal building were drawn up around this time, but the construction work was not put out to tender until such an ambitious development could be justified.

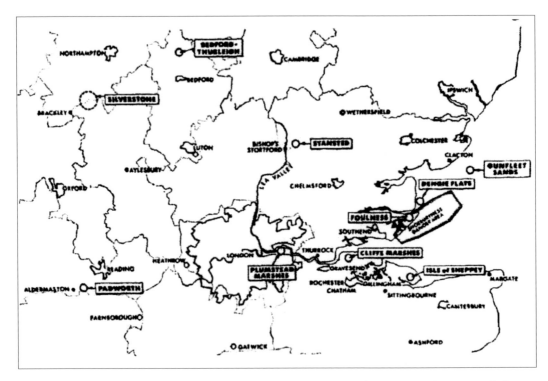

Diagram showing the various sites mentioned in the White Paper, 'The Third London Airport' of 1967. (Via author)

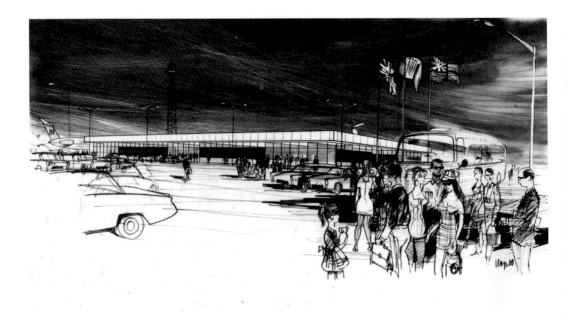

A 1968 artist's impression of the extended interim terminal. (BAA)

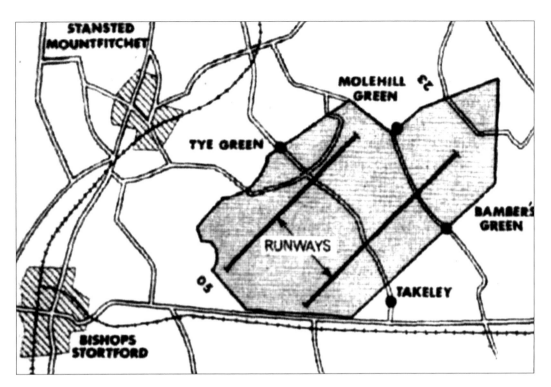

The area of land thought likely to be needed for the initial expansion of Stansted with two runways, as proposed in 1967. The upper of the two runways depicted is the existing one. (Via author)

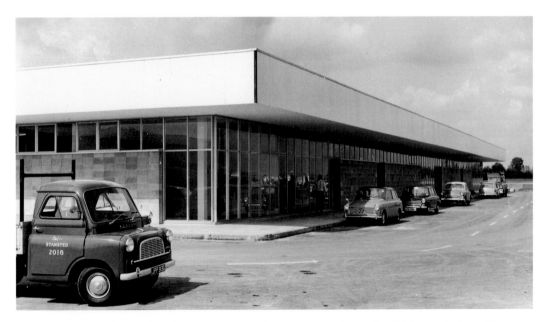

The interim terminal building in 1969, with a selection of period vehicles parked outside. (BAA)

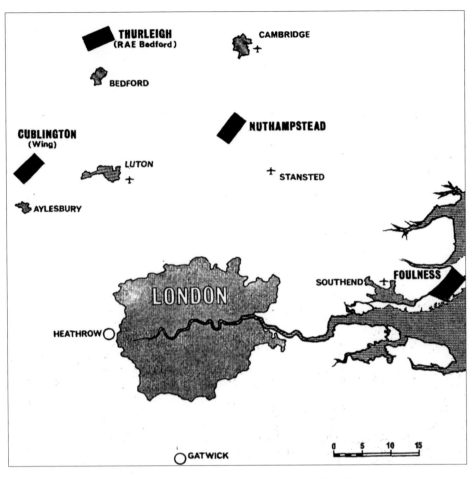

The four sites for London's third airport short-listed by the Roskill Commission in 1969. (Via author)

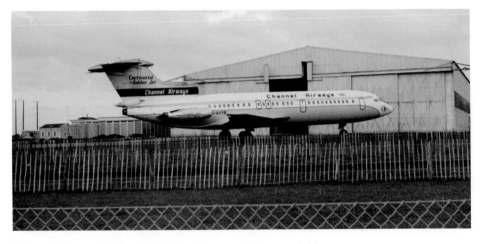

Channel Airways Trident G-AVYB at Stansted. (Dave Welch)

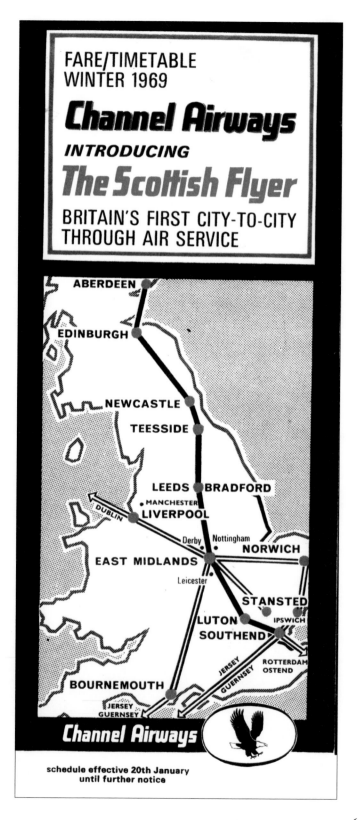

Cover of Channel Airways timetable showing the 'Scottish Flyer' links from Stansted in 1969. (Via author)

STN-9985F. Boeing 707 N9985F at Stansted in August 1976. (Via Dietrich Eggert)

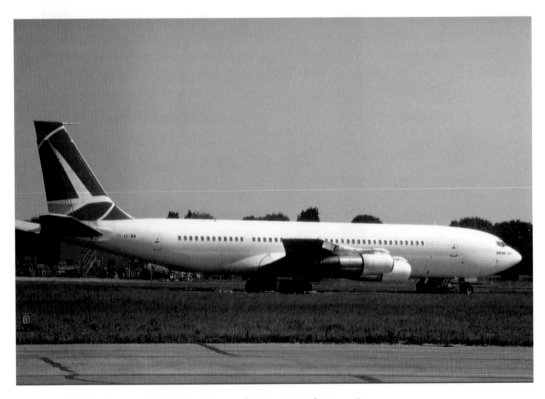

STN-YR-ABC. Boeing 707 YR-ABC at Stansted. (Via Dietrich Eggert)

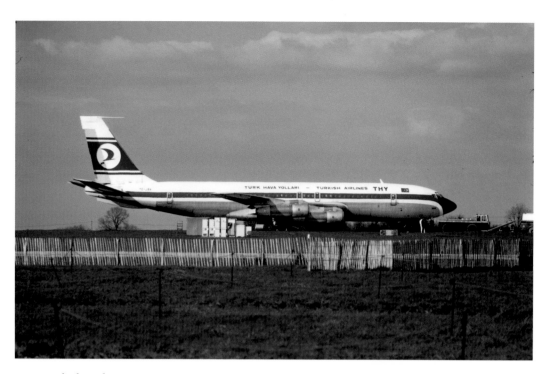

Turkish Airlines Boeing 707 TC-ABA at Stansted. (Via Dietrich Eggert)

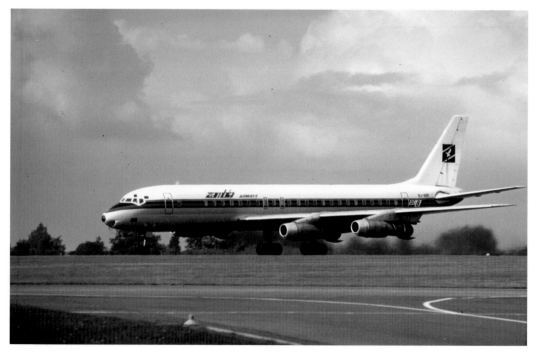

Zambia Airways DC-8 9J-ABR landing at Stansted. (Via Dietrich Eggert)

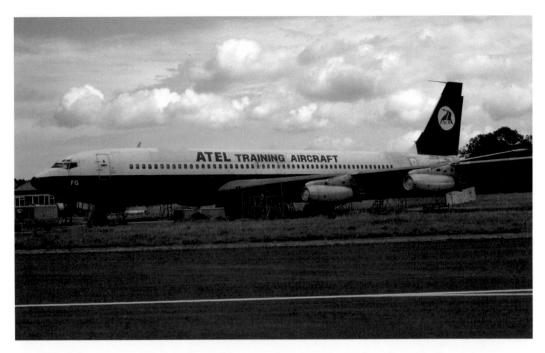

Former British Airtours Boeing 707 G-APFG used by Aviation Traders for ground training at Stansted. (Via Dietrich Eggert)

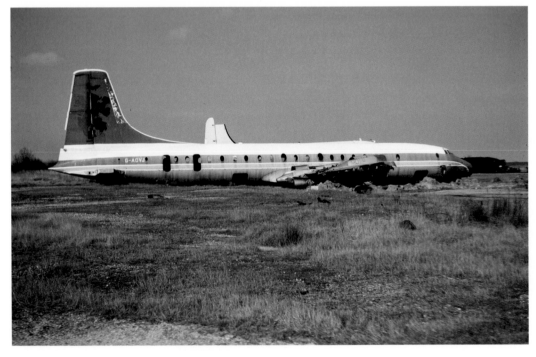

Former British Caledonian Bristol Britannia G-AOVJ on the Stansted fire dump. (Via Dietrich Eggert)

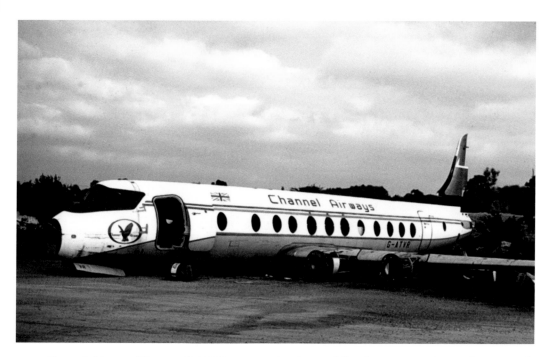

Channel Airways Viscount G-ATVR seen on the Stansted fire dump in April 1973. (Via Dietrich Eggert)

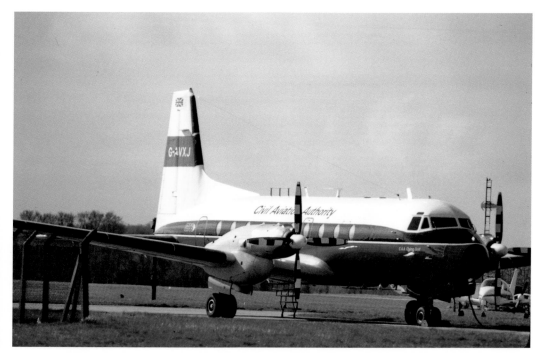

HS748 G-AVXJ of the CAA Flying Unit. (Via Dietrich Eggert)

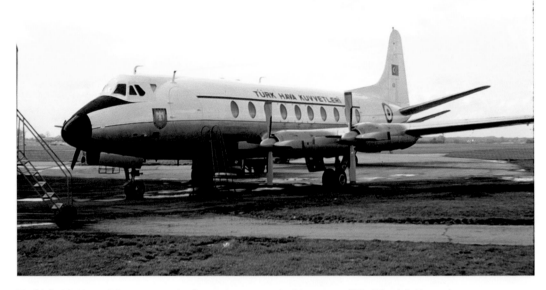

Turkish Air Force Viscount 431 in for maintenance in May 1977. (Via Dietrich Eggert)

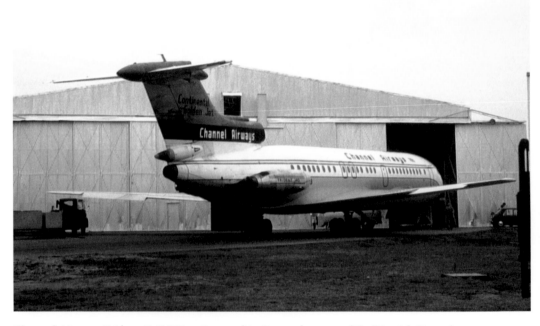

Channel Airways Trident G-AVYB at Stansted in September 1971. (Via Dietrich Eggert)

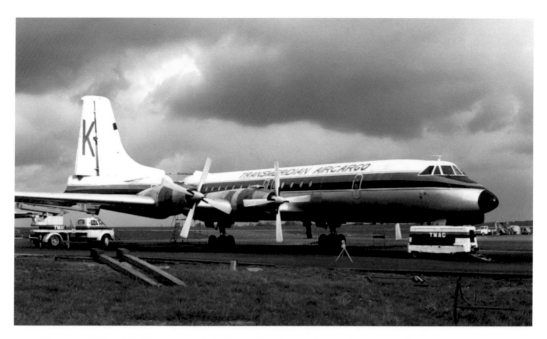

Transmeridian Air Cargo Canadair CL-44 freighter G-AZIN. (Via Dietrich Eggert)

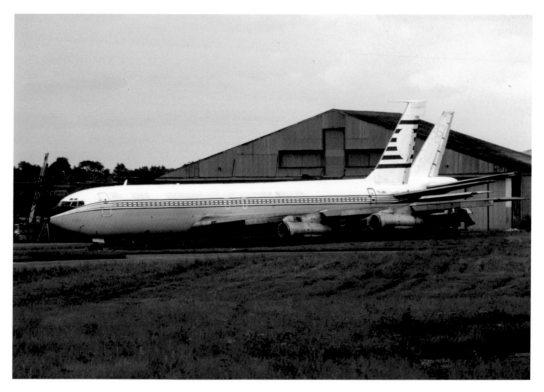

Former Turkish Airlines Boeing 707 TC-JBU and a DC-8 at Aviation Traders. (Via Dietrich Eggert)

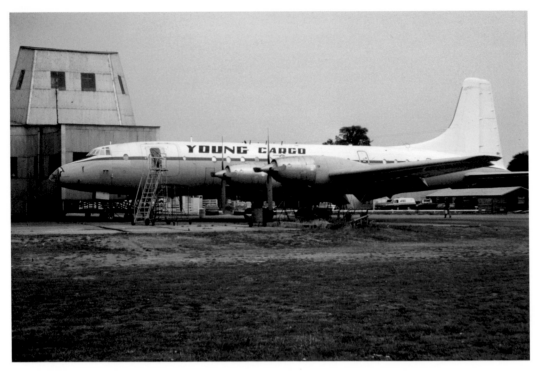

A former RAF Britannia of Young Cargo at Aviation Traders. (Via Dietrich Eggert)

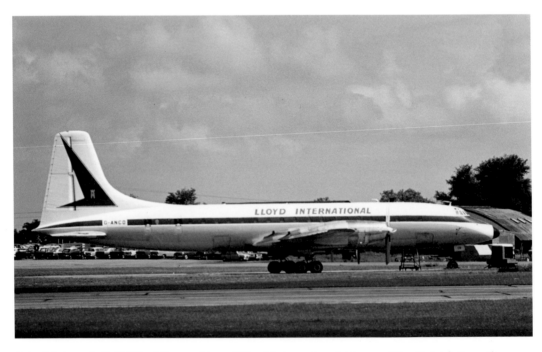

Bristol Britannia G-ANCD of Stansted-based Lloyd International Airways. (Via Dietrich Eggert)

Moving Into the Big Time

1977 started with another Boeing 747 visit, when a baggage handlers' strike at Heathrow caused the diversion of ZS-SAO of South African Airways into Stansted on 10 January. During that summer, almost all of the passenger activity at the airport took place at weekends, with incoming charters from Scandinavia dominating the movements. Frequent visitors were Boeing 720s of Conair, DC-8s of Scanair, Fokker F 28s of Linjeflyg, and Fokker F 28s and Boeing 737s of Braathens. Air Malta Boeing 720s also appeared on a regular basis. Stansted was also preparing to be the departure point for Freddie Laker's revolutionary Skytrain low-cost service to New York. When approval for the service had been granted in 1972 Stansted was specified as the UK terminus, but ever since then Freddie Laker had been battling for permission to use Gatwick instead. By early September 1977 this had not been forthcoming and the inaugural Skytrain service was due to depart Stansted on 26 September. The BAA had spent £15,000 on facilities to handle the wide-bodied DC-10 flights, but a last-minute appeal resulted in permission for Skytrain to use Gatwick instead, and so Stansted had to wait again for scheduled passenger services to North America. Charter activity continued to develop however, and in April 1978 the Israeli national airline El Al commenced Boeing 707 charters to Tel Aviv on a weekly basis. The airport's other role as a diversionary alternative to Heathrow was put to the test on 23 August 1978, when a strike at London's main airport caused the diversion of thirteen flights into Stansted. These included eight Boeing 747 services, and at one point there were four of these aircraft on the tarmac at the same time. In all, around 5,000 diverted passengers were handled that day. During the year there were aircraft accidents for the emergency services to deal with.

On 27 February, a Monarch Airlines One-Eleven was engaged on crew training sorties at the airport, and at the conclusion of one of these it was landed with the undercarriage still retracted. An accident with more tragic consequences took place on 4 September. An executive Cessna 421 was airborne from Cambridge on a test flight in connection with the renewal of its Certificate of Airworthiness. It had made several approaches at Stansted, and was in the process of overshooting after one of these when the starboard engine cut out at 200ft. The aircraft lost height and crashed just outside the airport boundary, killing the flight test observer and injuring the pilot.

In November 1978, Air Anglia extended its Aberdeen–Norwich scheduled service to Stansted. Aviation Traders Engineering had by now been sold by British & Commonwealth to Aer Lingus, and was continuing its recovery and expansion. The facility at Stansted was now a CAA-approved inspection organisation and a Federal Aviation Administration approved repair station, and was specialising in work on Boeing 707s in particular. More than half of its work came from overseas clients including Pan-American Airways, which was to become its biggest customer at this time. Pan-American was in the process of selling off its ageing Boeing 707 fleet, and those destined for new owners in the western hemisphere were usually sent to Stansted heavy maintenance and preparation. Aviation Traders were also responsible for the work necessary to bring the first Douglas DC-8s onto the UK register, for service with IAS Cargo Airlines.

In 1978, a new White Paper on London's third airport saw Maplin virtually discarded in favour of one of three preferred options: The expansion of Stansted to raise its passenger capacity from the existing 300,000 per annum to four million per annum. The development of a completely new site. The conversion of an existing military base. Yet another committee was set up to consider these and other possible options. Known as the Advisory Committee on Airport Policy, it published its report towards the end of 1979. This time Stansted was firmly recommended for development, although Maplin, previously rejected on grounds of cost and access, was also once again a possible contender. In the meantime, work commenced in August 1979 on resurfacing of the runway at Stansted. This entailed the closure of the airport between 2200 and 0700 each night, and when the task had still not been completed by the end of the year the remaining work was put on hold for some months. During 1979, Thurston International opened a base at Stansted to handle corporate aircraft up to Boeing 707 size. A twenty-four-hour operation was offered, and on one day in 1980 there were no less than seven executive 707s at Stansted. The main type handled, however, was the Gulfstream 3, accounting for 50 per cent of the company's workload. During 1980, Thurston handled some 500 aircraft movements, each with an average of six passengers aboard. On 10 January 1980, industrial action by maintenance staff at Heathrow brought more diverted flights into Stansted. These included two Concorde flights, the first visits by the supersonic airliner. For the winter of 1979/80 Air Anglia was operating scheduled services by F-27 turbo-props linking Stansted to Aberdeen via Norwich, Leeds/Bradford and Edinburgh, but in January 1980 the airline was merged with British Island Airways and some smaller carriers to form Air UK, an airline that was to do much to boost Stansted's traffic in coming years. The service to Aberdeen was dropped for the winter 1980/81 timetable, but on 2 November 1981 Fokker F-27 G-STAN inaugurated a twice-daily Stansted-Amsterdam service, the first international scheduled passenger service out of Stansted for ten years. During 1979, Trans-Meridian had merged with Gatwick-based IAS Air Cargo to form British Cargo Airlines, the largest all-cargo airline in Europe. In March 1980 heavy losses forced this company into receivership, but before this happened a new company called TAC Heavylift (later changed to Heavylift Air Cargo) had been formed at Stansted to operate freight services with former RAF Short

Belfast heavy transports. By November, two examples were in service, one based at Stansted and one at Singapore. The company set up its headquarters in the former TAC building at Stansted, and in later years it was to form an association with the Russian airline Volga Dneper to offer Ilyushin IL-76 and Antonov AN-12 freighters for charter. During 1980, the BAA submitted plans to develop the existing terminal facilities at Stansted to cater for up to 15 million passengers each year. It stated that no major redevelopment work would be needed, just expansion of the apron to accommodate up to fifty aircraft at a time, increased car parking space for up to 4,000 vehicles, and possibly an airport hotel. In 1981, Sterling Airways transferred its Scandinavian charter flight programme from Luton Airport to Stansted, inaugurating five-times-weekly services with Boeing 727s and Caravelles from 3 April. Another organisation specialising in handling corporate aircraft at Stansted was CSE Aviation. By 1981, the company had invested some $2 million in its Jet Centre at the airport and had a staff of fifteen engineers looking after aircraft up to Gulfstream 2 size. Its premises in Airways House offered extensive facilities for clients, including overnight crew accommodation, a lounge and conference room, and flight planning services.

In 1982, there were two potentially fatal events at the airport, which fortunately ended without loss of life. An Air Tanzania Boeing 737 was hijacked *en route* from Mwanza to Dar-es-Salaam on 26 February and flown via Nairobi, Jeddah and Athens to Stansted, touching down there at 1431 on the following day. During the course of 28 February, the ninety-nine hostages aboard were gradually released, and at 1622 the hijackers surrendered. The aircraft was allowed to return to Tanzania on 3 March. On 5 September, Douglas DC-8 RP-C830 of Intercontinental Airlines was on approaching runway 23 at Stansted in fog and poor visibility at the conclusion of a passenger charter from Lagos with fifty-eight passengers and fifteen crew aboard. Upon reaching decision height the crew initiated a missed approach procedure, but whilst overshooting the aircraft struck another DC-8, N786FT of Flying Tiger Lines, which was parked on the cargo apron. Substantial damage was done to both aircraft and the Intercontinental Airlines DC-8 diverted to Manchester where a safe landing was made. During the financial year 1982/83 Stansted handled 299,000 passengers, with some 72 per cent of these travelling from or to Scandinavia. August was the busiest month, with 33,175 passengers passing through the terminal. There were now five scheduled passenger routes from the airport, but charter traffic still predominated. Cargo traffic was also up, with 7,700 tons passing through. In the summer of 1983, Air UK was operating scheduled services from Stansted to Paris, Brussels and Amsterdam, and had announced its intention of developing a major traffic hub at the airport with at least eight departures daily. In addition, Jersey European Airways operated a summer service to Jersey and Guernsey with Twin Otter aircraft. Throughout the 1980s, Air UK continued to open more routes out of Stansted, using leased One-Eleven and Fokker F 28 jets and turbo-prop Shorts 330s and 360s and Fokker F-27s. The airline also brought the first BAe 146 jets into Stansted, and this type was to become the mainstay of Air UK's services until the introduction of the Fokker 100 in 1993. On 5 June 1983, Stansted played host to the

NASA space shuttle *Enterprise* and its Boeing 747 carrier aircraft. The combination was on static display at the airport for two days, during which some 250,000 people came to see it, causing the M11 motorway to be brought almost to a standstill.

In yet another White Paper in 1985 the government finally announced its unconditional approval of the development of Stansted as the third airport for London. The passenger capacity was initially limited to 8 million passengers per annum, but on 5 June 1985 planning consent was given for developments that would eventually allow passenger throughput to be increased to 15 million each year. The number of flights each year was to be restricted to 78,000 each year. Early in 1985, start-up carrier London Express took office space in Airways House and announced its intention of commencing passenger services between Stansted and Singapore in 1986. A Boeing 747-100 was to be used for the flights, which would make a refuelling stop at Sharjah. Several tour operators signed contracts for seat allocations on the flights, but the start-up date kept being postponed and the service was never to operate. In 1985, Aviation Traders hired half of the former CSE hangar, the first work carried out there being a major overhaul of Andover XS646 operated by the Royal Aircraft Establishment. During late 1985 and early 1986, the One-Elevens of British Island Airways were overhauled, and during 1986 the company fitted new floor lighting to six Airbus A310 and five Boeing 737 aircraft of Pan American Airways, and in August of that year seven Boeing 707s and three DC-8s of various operators were worked on. At the end of March 1987, Aviation Traders (Engineering) Ltd was taken over by Cambridge-based Qualitair Aviation (Holdings) Ltd. The new owner announced that work was to begin straight away on new facilities at Stansted, including a new hangar large enough to accommodate two Boeing 747s or ten Boeing 737s. The cost of the new facilities was to be around £17 million, and up to six hundred staff were to be employed there. On 14 August 1987, the company name was changed to Qualitair Aviation Ltd.

During the financial year 1984/85, 547,000 passengers passed through Stansted, an increase of 53 per cent on the previous year. Transatlantic passengers increased tenfold, being carried during the summer of 1985 on Boeing 747s of TransAmerica and Wardair and DC-8s of Capitol Airways and aircraft of other carriers such as Worldways. American Trans Air was also to have used DC-10s and Tristars on charters to the USA, but then axed their entire programme. Freight traffic at the airport also received a boost in 1985 when Federal Express commenced Memphis–New York (JFK) – Gander–Stansted–Brussels schedules. Boeing 727-200s fitted with extra fuel tanks and specialised navigation equipment operated as far as Stansted, but Federal Express (FEDEX) was not permitted to carry UK-originating cargo to non-US countries, so the Stansted–Brussels–Stansted legs were operated on their behalf by Talair using smaller aircraft. The FEDEX Boeing 727s were replaced by larger DC-10s from 29 October 1985. Monarch Airlines suffered another mishap on 20 September 1985. One-Eleven G-AXMG had been with Aviation Traders for attention and had taken off on a positioning flight to Gatwick when the crew announced that the nose undercarriage had not locked after retraction. An emergency landing with the nosewheel up was made back at Stansted and the aircraft was taken back to Aviation Traders. During November 1985, DC-8-62 jets of the US carrier Arrow

Air transited Stansted *en route* from Sigonella in Italy to Norfolk Naval Air Station in Virginia, and in December a Short Belfast freighter of Heavylift carried a satellite earth station antenna from Stansted to Khartoum for the BBC in connection with their Christmas Day broadcast from the Sudanese relief camps. During that winter, however, there were some service losses for the airport. On 14 November 1985, Air Express International operated their last CL-44 freighter flight into Stansted, their UK terminal then being transferred to Manston in Kent, and at the end of the year Air Atlantique also moved out to a new base at Coventry Airport. Their last revenue service before the move was a cargo service to Brussels using Dakota G-AMPY on behalf of FEDEX.

On 7 March 1986, former British Airways Trident 3 G-AWZU arrived at Stansted for use by the airport fire service. Early that year handling agents GH Handling set up an operation at Stansted under the name of GH Stansted to handle all of Dan-Air's charter programme for the summer of 1986. After the completion of this programme a staff of thirty-five was kept on at Stansted to handle ad hoc charters and the occasional Evergreen and Worldways transatlantic flight. In May 1986, regular aircraft movements through Stansted included:

Kondair newspaper flights to Amsterdam using Trislanders and a Cessna Titan.
Dan-Air One-Eleven holiday charters to Faro, Mahon, Palma, Ibiza and Malaga.
Saturday night newspaper flights to Belfast by Merchantman freighters of Air Bridge Carriers.
Fordair corporate flights to Cologne and Valencia by One-Elevens and to Maastricht, Liverpool, Cologne and Coventry by Gulfstream 1s.
FEDEX DC-10 freighters from Memphis on three days each week.
Wardair Boeing 747 charters to Toronto on Saturday afternoons.
Braathens Boeing 737 charters to Oslo, Gothenburg and Stockholm (Arlanda).
Hispania Boeing 737 charters to Palma and Tenerife on Tuesdays.
Balkan Airways TU-154 flights to Bourgas on Saturday evenings.
Conair Boeing 720 flights to Copenhagen on Saturday evenings.
Sterling Airways Boeing 727s to Stockholm on Sunday evenings and Caravelles to Copenhagen on Friday and Sunday mornings.
Scanair Airbus A300 to Stockholm on Sunday evenings.
Maersk Air Boeing 737 to Malmo on Sunday evenings.
Transwede Caravelle to Gothenburg on Sunday evenings.
British Air Ferries Viscount to Jersey on Sunday mornings.
Aviogenex TU-134s to Split on Saturday evenings and Boeing 727 to Pula on Sunday evenings.
Jersey European Airways Shorts 330 to Jersey on weekday mornings.
Aviaco Boeing 737 to Palma on Saturday afternoons.
Securicor/Skyguard Herald freighter from Birmingham and on to Brussels on Tues–Fri evenings.

From the above it will be seen that weekends were still by far the busiest times at the airport.

During June 1986, Pan American Airways began using Stansted for Airbus A310 crew training sorties.

In 1986, cargo airline Tradewinds Airways was acquired by the chairman of Tal-Air and the headquarters of the combined organisation was moved into the Tal-Air office accommodation at Stansted. The company announced its intention of basing its entire operation at Stansted, acquired a Boeing 707, and made application to the CAA for licences for services from Stansted to Chicago and Khartoum. Twice-weekly services to Chicago duly began on 17 May 1986. During September of that year Tal-Air was also operating flights each weekday night on behalf of UPS, who had taken over a portakabin at Stansted. The Tal-Air Bandeirante turbo-prop connected with an incoming UPS flight at Cologne and transported UK-bound cargo to Stansted, where it was sorted in a Servisair warehouse. Some freight was then carried onwards on a Tal-Air aircraft, while the rest was loaded onto a Ryanair flight to Ireland. During November 1986, heavy pre-Christmas loads resulted in the use of a British Air Ferries Herald aircraft on nightly parcels runs, and that month also saw Connectair take over the Stansted–Liverpool mail contract from Air Ecosse. On 1 August 1986, Stansted airport officially passed into the ownership of BAA plc through a subsidiary Stansted Airport Ltd. In 1986, Stansted was at the centre of a plot to kidnap the deposed Nigerian Transport Minister Umaru Dikko and smuggle him out of the UK against his will. He was found unconscious and bound in a crate at the airport, having been drugged ready for transport to a show trial in Nigeria.

On 28 April 1987, a number of Rolls-Royce-powered aircraft past and present were on display at Stansted to publicise the launch of that company's shares on the London Stock Exchange. A marquee was erected on the airside of the security fence for the invited guests who came to view aircraft such as the Shuttleworth Trust's Hawker Hind, the Battle of Britain Memorial Flight's Spitfire, Hurricane and Lancaster, the Royal Navy Historic Flight's Fairey Firefly, Tornado, Buccaneer and Harrier aircraft of the RAF, a British Airways Boeing 757, executive jets, and the last airworthy Avro Vulcan. The airport was closed for an hour for flypasts by many of these aircraft plus a British Airways Concorde and a QANTAS Boeing 747. On 21 June 1987, Boeing 747 G-HIHO arrived at Stansted for the new UK airline Highland Express. Scheduled services to Newark Airport, New York, began nine days later, but the airline was plagued by technical delays to its solitary aircraft and went into Receivership on 1 December 1987. In August 1987, Field Aviation, part of the Hunting Group of Companies, purchased the Tal-Air Group Holdings maintenance, fuelling and aircraft handling operations at Stansted. All of the staff were kept on by the new management. In November, Air UK transferred its operations department from Norwich to Stansted, followed in the spring of 1988 by the airline's administrative headquarters. The premises at Stansted also became the headquarters of Air UK Leisure, which began holiday flight operations from Stansted with two Boeing 737s on 30 April 1988. In 1988, Titan Airways was formed, with a single Cessna Titan aircraft and offices in Enterprise House at Stansted. On 15 November 1988, a lady arriving from Amsterdam

became the one-millionth passenger to pass through Stansted in a twelve-month period, the first time this figure had been achieved. During the financial year 1988/89 some 1,124,000 passengers transited the airport, a 55 per cent increase on the previous financial year. There were now charter services to eight Caribbean destinations as well as Florida, New York, Hawaii, Canada, Malaysia and East Africa, although many of these were seasonal operations. For a three-week period from 19 August 1988 archaeologists were allowed access to the site of a new short-term car park under construction at the airport, where traces of the tomb of a wealthy Roman landowner had been discovered during excavation. The search for artifacts unearthed coins, pottery, engraved gemstones, and pieces of bronze. Later on, the remains of nine Celtic round houses were discovered on the site of the present-day main aircraft apron.

On 22 May 1989, the first phase of a new £4.5 million cargo centre was opened by Lord Brabazon of Tara, the Minister of State for Aviation. This initial phase comprised a bonded warehouse 9,000 sq.ft in area with the capacity to handle 100,000 tons of freight annually. The complex was designed and built by J. A. Elliott of Bishops Stortford, and had stands for eight freighters of Boeing 747 size. Also in May 1989, the new £20 million Diamond aircraft servicing facility was opened by FLS Aerospace (formerly Qualitair Aviation). FLS was later taken over completely by the FFV Group and renamed FFV Aerotech Stansted, and then became FLS Maintenance Ltd, a subsidiary of Aer Lingus, in November 1991. The hangar was of diamond or double-triangle shape, with a clear span of 170 metres, enabling it to accommodate two Boeing 747s side by side or up to nine aircraft of Boeing 737 size.

Another significant date for the airport in 1989 was 30 May, when Ryanair commenced operations into Stansted. Initially, flights from Knock in Ireland were operated on three days each week with leased One-Eleven jets, but before long Ryanair was competing with Aer Lingus on the Dublin route, although at this stage the airline had not adopted its current low-cost model for operations. In July 1990, the Stansted Harlequin Hotel (later to become the Hilton National Stansted Hotel) was opened on land situated between the airport and the M11 motorway. By August 1990 Stansted had 167 scheduled flights each week, serving seventeen destinations. During that month 43,930 passengers were handled, a 15 per cent increase on August 1989. It was not until January 2009 that secret Ministry of Defence documents were published revealing that on 30 June 1990 seven callers independently contacted the airport to report sightings of a suspicious object in the sky over Stansted for a period of ten minutes or so. One call was from a serving member of the RAF who was fishing with his uncle by a lake near the airport. He said that the object came within 200 yards of them, but made no sound. On 19 February 1991, a new training centre for airport staff was opened in the former Blunt's Farmhouse, which had been purchased by the BAA as long ago as October 1980. A new seven-bay airport fire station also opened on 15 April that year. It was situated next to the cargo centre and replaced the one on the other side of the runway which had become too small to accommodate the predicted increase in appliances and personnel.

VIEW 3
NOV 2006

BAA Stansted
STex
Delivering
a better airport

The Design Solution
DESIGNERS AND ARCHITECTS

Mesh canopy at Bangkok
Suvarnabhumi airport

1976 artist's impression of proposed terminal extension in 2008. (BAA)

Terminal Facilities Plan

INTERNATIONAL PASSENGERS

PORT HEALTH & V.I.P. FACILITIES

SKYSHOP

DOMESTIC PASSENGERS

TOILETS

DUTY AND TAX FREE SHOP

INTERNATIONAL DEPARTURES LOUNGE

LANDSIDE RESTAURANT BUFFET & BAR

BAR/ CAFE

IMMIGRATION

DOMESTIC DEPTS LOUNGE TOILETS IMMIGRATION

TOILETS

BAGGAGE RECLAIM

SECURITY

DOMESTIC BAGGAGE RECLAIM

CHECK-IN DESKS

BANK TOILETS

INFO DESK H.M. CUSTOMS CHANNELS

LANDSIDE CONCOURSE

CHECK IN HALL TOILETS

TOILETS

INTERNATIONAL ARRIVALS CONCOURSE

SKYSHOP CAR HIRE TAXIS

LANDSIDE FORECOURT

1986 diagram of the proposed interior layout of the new terminal building. (BAA)

Landside / Airside Section

1986 north/south sectional plan of the new terminal building. (BAA/Foster Associates)

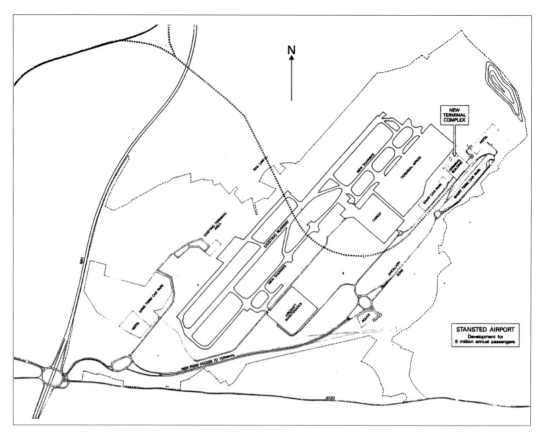

Above: 1986 map of proposed new airport layout incorporating the new terminal building. (BAA)

Opposite above: Boeing 707 freighter G-BNGH of Tradewinds Airways in October 1987. (Via Dietrich Eggert)

Opposite below: Emery DC-8 freighter N865F in July 1984. (Via Dietrich Eggert)

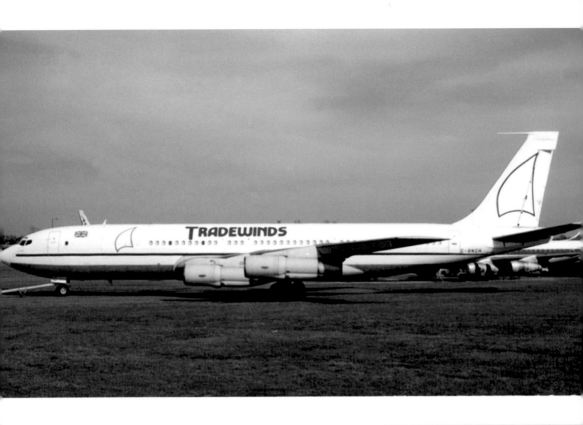

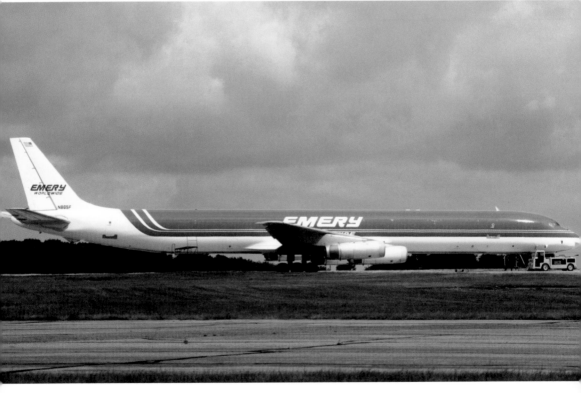

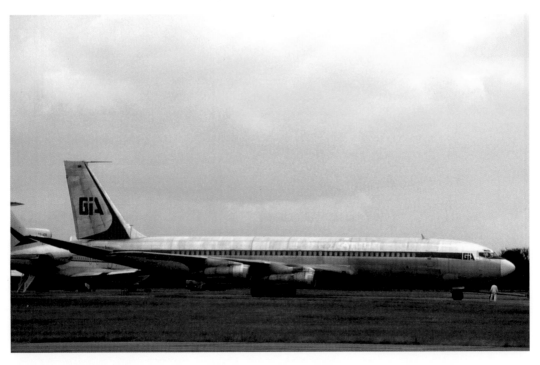

Boeing 707 N8417 of GIA in a neglected state at Stansted in July 1984. (Via Dietrich Eggert)

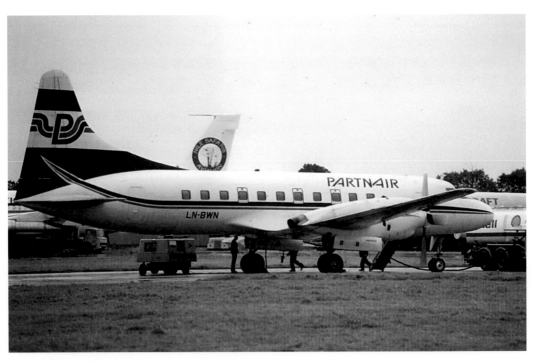

Convair 580 LN-BWN of Partnair, a regular visitor on Scandinavian charters. (Allen Clarke)

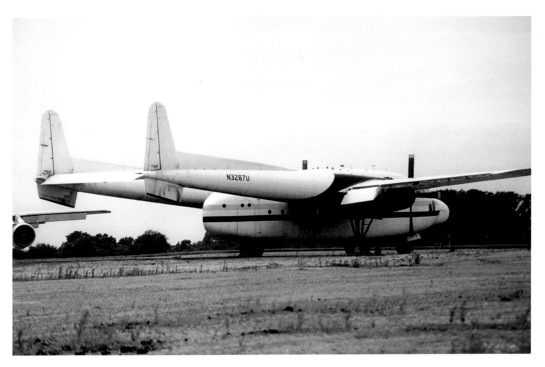

A visit from a rare type in the UK, Fairchild C-119 N3267U. (Allen Clarke)

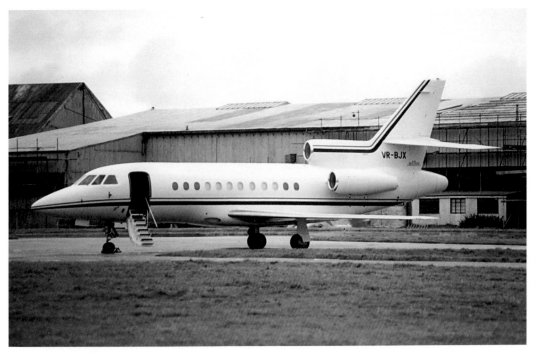

One of the many executive jets to visit Stansted, Falcon 500 VR-BJX. (Allen Clarke)

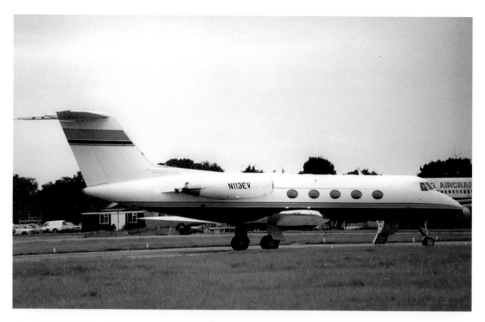

Grumman Gulfstream 2 N113EV, one of the many 'biz-jets' seen at Stansted. (Allen Clarke)

The BAA's mobile display stand, promoting the range of services and facilities at Stansted in 1982. (BAA)

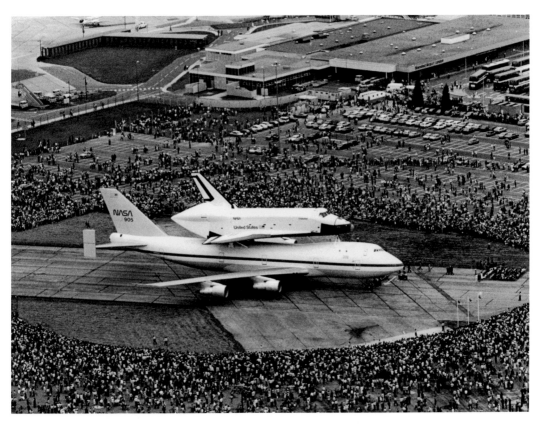

The NASA space shuttle *Enterprise* and its carrier Boeing 747 on display at Stansted in June 1983. The interim terminal and car park visible in the background. (BAA)

Fordair executive One-Eleven G-BEJW outside their hangar in May 1984. (Derek Heley)

HIGHLAND
EXPRESS

TO

NEW YORK
AND
TORONTO

747
SCHEDULED SERVICES

SYSTEM TIMETABLE

30th May to 24th October 1987

Cover of the Highland
Express timetable
for their short-lived
transatlantic services
from Stansted in 1987.
(Via author)

Our £400 million investment in space.

The countdown for more space began 15 years ago and ends just 12 months from now with the launch of the new London Stansted Airport.

The star of the whole complex is without a doubt the stunning new terminal building.

Once inside you'll quickly realise that its comfortable and relaxed atmosphere owes as much to the simplicity of its layout as it does to its light and airy construction.

Everything you need is on one level. As a departing passenger you walk in a straight line from the entrance through check-in, security and passport control to the departure lounge all within a distance of 150 metres. On arrival you cover the same distance through immigration, baggage reclaim and out to the forecourt.

To ensure that the whole of your journey through Stansted will be just as effortless, an automatic tracked transit system will quickly carry you between the terminal and the departure satellites out on the apron.

And these will not be the only trains that you'll see at the new London Stansted.

A new direct rail link will mean that the journey from Liverpool St. Station in the City will take you just 40 minutes. And to the North there will be direct connections to Cambridge, Peterborough, Birmingham, Manchester and Liverpool.

If you prefer to drive, Stansted's location couldn't be better. It's right by the M11 and just 15 minutes from the M25.

But however you get there one thing's for sure, you and your clients will find an airport that's out of this world.

B·A·A

Stansted

Stansted Airport Limited, Stansted, Essex CM24 8QW.

LONDON'S THIRD AIRPORT · SECOND TO NONE.

1990 BAA advertisement for the forthcoming new terminal facilities. (BAA)

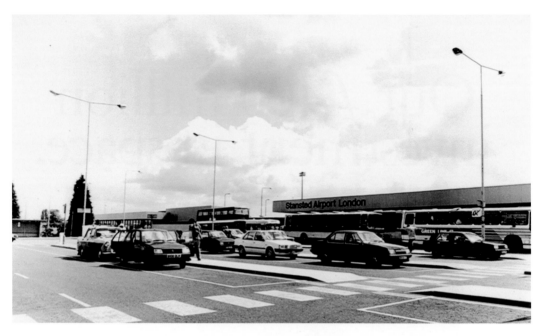

A view of the interim terminal in 1984, with period cars and coaches outside (BAA)

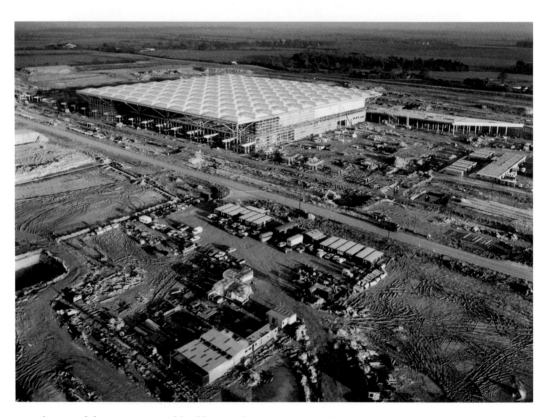

Aerial view of the new terminal building under construction. (BAA)

The New Terminal Opens

On 20 January 1991, the almost-completed new terminal building was the venue for a recording of the BBC TV programme *Songs of Praise*. The terminal was officially opened by HM The Queen on 15 March 1991. A planned flypast of RAF aircraft types was cancelled because of the Gulf crisis of that time, and replaced by a demonstration by a single Harrier. Four days later, the first paying passengers entered the new building, many of them bound for Malta on a Leisure International Boeing 737 charter, but the actual first departure from the new terminal was an Air UK BAe 146 flight to Glasgow, which left at 0720. The first arrival was an Air France service from Paris, which touched down at 0740. With the entry into service of the new terminal the interim terminal was modified for use as an executive aircraft terminal. The terminal was designed by architect Sir Norman Foster's company and was his first airport terminal project. The project was formally inaugurated on 15 April 1986, the press conference to reveal details of the design on 28 May that year being timed to coincide with the BAA's application to Uttlesford District Council for detailed planning consent. Strict environmental regulations restricted the height of the building to no more than the height of the surrounding trees, so it had been necessary to have the building partially sunk into the ground to a depth of twelve metres to reduce its environmental impact. To this end, around 1.5 million cubic metres of soil had been excavated over a nine-week period. This was used for landscaping around 10 per cent of the total area of the development. Around 250,000 trees and shrubs were planted and particular attention was given to preserving or relocating existing grasslands, hedgerows and woods, with acknowledged specialists being commissioned by the BAA for this purpose. The design brief for the new terminal was to present a spacious interior appearance, with all passenger activity on one floor and the maximum walking distance 150 metres or less. The building was completely glazed to ensure the maximum amount of natural light during daytime, and after dark illumination was provided by indirect lighting. The roof domes (18 metres squared) were supported by thirty-six steel 'trees'. This arrangement allowed the main concourse to be kept uncluttered, with all heating, lighting and other essential service equipment located on the lower floor, along with the train station. This was situated below the front entrance, allowing speedy access to the Stansted Express rail link to

London Liverpool Street station. The radical design of the terminal allowed for future expansion by the addition of modular extensions on either side without disruption of operations, and an AEG Westinghouse 'people-mover' transported passengers between the main terminal and the airbridge-equipped satellite building, which was initially used for international flights only. The 'people-mover' carriages could operate as single units or be linked together to form two- or three-coach trains, dependent on demand. Within a month or so of the opening of the new terminal the number of scheduled services into Stansted had more than doubled, and by May 1991 there were 676 flights each week to twenty-five European destinations, operated by Air UK, Ryanair, Crossair, Air France, Proteus, Noble Air and TAT. However, the airport still lacked any transatlantic scheduled passenger services. On 8 July, British Rail opened new rail links from Stansted to Cambridge, Peterborough, the Midlands, and the north of England. From 20 September 1991, a new Category 2/3 Instrument Landing System came into operation, greatly aiding landings in poor visibility. During the period 1–3 October 1991 Stansted was the venue for the first European Business Air Show. Twenty-eight corporate aircraft ranging in size from Learjet to Boeing 707 were on show outside the Business Aviation Terminal. Nearly 1.7 million passengers passed through the airport during the course of 1991.

On 18 February 1992, the long-haul subsidiary of Air UK was launched as Leisure International Airways. Long-haul charter operations commenced in April 1993, and from 1996 the Leisure International name was also used for the short-haul charter services until then operated by Air UK Leisure. During 1992, Field Aviation began work on a new maintenance base and offices at Stansted. The company was part of the Hunting Group of Companies, and in early 1993 Hunting renamed all of the Fields companies as Hunting Business Aviation. On 18 September 1992, the refurbished former interim passenger terminal was officially opened as a business aviation terminal. The refurbishment had been carried out by Esso, and the building was named the Avitat Centre, the brand name for all the Esso business aviation terminals in the UK. It was managed by Hunting Business Aviation, who provided the engineering services, and its eleven aircraft stands could accommodate anything up to the size of a Boeing 747. Twenty-four-hour servicing and maintenance of smaller business jets was also provided by Inflite, who employed 150 staff at their Executive Jet Centre, a much-developed wartime hangar. Traffic at the new cargo centre continued to expand. The amount carried in May 1992 was 30 per cent up on the May 1991 figure, and major users of the terminal were Fedex, UPS, Aeroflot and Heavylift Cargo. On 16 June, Stansted finally got its first scheduled transatlantic passenger service when American Airlines used Boeing 767-200 N328AA to inaugurate a daily service from and to Chicago. Over 20,000 passengers were carried during the first three months of operation, but the average yield per passenger was low and losses of some $10 million had been accrued by the time the service was suspended on 31 May 1993. During 1992, the CAA brought into operation a new £1.3 million surface-movement radar, whose Thomson-CSF scanner provided detailed coverage of ground movements across the airfield. This equipment

was part of a four-year programme of investments that eventually led to the opening of a new air traffic control tower in 1996.

The mid-1990s saw more new start-up airlines including Stansted in their route networks, although several of these operations were short-lived. During the summer of 1994, Bournemouth-based Euro Direct Airlines commenced services from Stansted to Hamburg, and to Brussels via Humberside, using Jetstream 31 and ATP turbo-prop aircraft. By the winter of 1994/95 the airline was flying from Stansted to Hamburg, Berne and Kortrijk, but all operations ceased on 26 February 1995. Another new name was Aberdeen-London Express, which was founded by former Bishops Stortford resident Dr Robert Perryment. A leased One-Eleven srs 500 was used on daily services between Aberdeen and Stansted at a fare of £60 each way. However, promised support from oil companies in the form of block bookings did not materialise and the airline ceased operating on 6 December 1994. In March 1995, Air Belfast was launched as part of the Air Bristol group and provided daily One-Eleven srs 500 services between Stansted and Belfast. The company took office accommodation in Enterprise House at Stansted, but the service was discontinued on 21 March 1996. More successful new services were launched in 1995 by Ryanair and the Israeli national airline El Al. On 26 October, Ryanair inaugurated a low-cost Stansted-Prestwick service, the forerunner of many such services over the coming years, and in the same month El Al began using Stansted as a transit stop on its Tel Aviv–New York service. In November 1995, Metro Business Aviation was formed when Harrods Holdings plc acquired Hunting Business Aviation.

At the end of February 1996 the new control tower on the south side of the airport came into use. Construction of the 60-metre-high tower had commenced in December 1994, and the formal opening was performed by the BAA Chief Executive Sir John Egan on 17 May. At the time of its opening it was the tallest air traffic control tower in the UK, and it was said that in fair weather Canary Wharf in London could be seen from the top floor. The financial year ending 31 March 1996 was the best the airport had seen up to that time, with 4,129,971 passengers passing through, a 23 per cent increase on the previous financial year. Locally-based Titan Airways expanded into jet operations in April with the introduction of a BAe 146-200QC passenger/freighter to its growing fleet. 2 June 1996 saw the commemoration of the fiftieth anniversary of the opening of Heathrow by a flypast of representative types old and new along the runway there. Several of the participating aircraft used Stansted as their base for this event, including two De Havilland Rapide biplanes, the only airworthy Comet jet, a Bristol 170 freighter and a Concorde. The summer saw Stansted involved in another hijacking drama. Sudan Airways Airbus A310 F-GKTD, with 197 passengers aboard, was seized by six Iraqi nationals during a Khartoum-Amman service on 26 August, and after a refuelling stop at Larnaca the Airbus landed at Stansted at 0430 the following day. It was parked on the compass base near the FLS hangar while negotiations took place, which resulted in the release of all the hostages and the surrender of the hijackers.

By 1997, Air UK had become Britain's third-largest scheduled airline. With its main offices at Stansted House, the company operated services from Stansted to Aberdeen, Edinburgh, Glasgow, Inverness, Guernsey, Jersey, Amsterdam, Brussels, Copenhagen, Dusseldorf, Florence, Frankfurt, Hamburg, Madrid, Milan, Munich, Paris and Zurich, with the Dusseldorf and Paris services being operated by Gill Airways on their behalf. There were now two passenger-handling agencies at Stansted, GH Stansted and Servisair, which employed 435 staff and handled around 92 per cent of the total business. In October 1997, Classic Airways commenced operations with two wide-bodied Lockheed Tristars based at Stansted. The company had been set up to provide back-up aircraft at short notice to tour operators and airlines in need of extra capacity. Classic Airways operated under the Air Operators Certificate of British World Airways, but following a dispute BWA withdrew this facility and, from 20 August 1998, the two aircraft were grounded at Stansted. The airline entered receivership while it tried to raise fresh finance, but it never resumed operations. Much controversy was caused by British Airways when it announced in November 1997 that it was going to launch its own low-cost airline to compete with Ryanair and Easyjet. Barbara Cassani, British Airways General Manager in New York, was chosen by BA boss Bob Ayling to set up the new venture under the provisional project name of Operation Blue Sky and to run it as a completely separate, wholly-owned subsidiary of British Airways. In February 1998, it was announced that the new airline was to be called Go Fly Limited and would use a fleet of Boeing 737s on a network of services from Stansted. The inaugural service departed Stansted for Rome Ciampino on 22 May 1998, and other initial destinations included Copenhagen, Milan, Bologna and Lisbon, and a domestic route to Glasgow.

On 30 March 1998, the Leeds United football team had a lucky escape at Stansted. The club had chartered Emerald Airways HS 748 G-OJEM to take the team and supporting staff home to Leeds/Bradford airport after a match at West Ham. With forty passengers and four crew aboard the aircraft had just lifted off from runway 23 when the number two engine suffered a catastrophic failure and a fire in the engine nacelle. The crew elected to set the aircraft back down onto the remaining stretch of runway but it could not be brought to a halt before it crossed the perimeter track and came to rest with its nose undercarriage collapsed. The aircraft was a write-off, but there were no serious injuries to its occupants.

By 1999, Ryanair had expanded to become Stansted's largest operator, with over 600 flights each week carrying around 30 per cent of the airport's total passenger traffic. At Go Fly, however, mounting losses forced a change in strategy in June. The route network was pruned in favour of new summer holiday routes to Alicante, Ibiza and Palma, and new winter sports services to Lyon and Zurich were announced. The year was to end with a disaster. At 1836hrs on 22 December 1999, Korean Air Boeing 747-200 freighter HL7451 was cleared to take off from runway 23 at Stansted on a cargo flight to Milan Malpensa. After reaching an altitude of 2,532ft the 747 entered a progressive bank to the left and descended, striking the ground near Great Hallingbury with the loss of all four crew.

On 4 January 2000, a new rival to Go Fly, Easyjet and Ryanair commenced operations. Buzz had been launched in 1999 by KLM as a sub-brand of KLM UK to operate many of the point to point routes on the KLM UK network on a low-cost basis. Based at Endeavour House at Stansted, the new airline had an initial fleet of eight BAe 146s transferred from KLM UK. On 27 October 2002, KLM UK transferred its Stansted–Amsterdam route to Buzz, whose fleet by then included six leased former Continental Airlines Boeing 737s. In the end, however, the competition from the more established low-cost airlines proved too much, and on 31 January 2003 KLM announced its intention of selling Buzz to Ryanair for an estimated 20.1 million euros. Following approval from the Office of Fair Trading the sale was completed on 10 April 2003. Ryanair acquired all the Buzz landing slots at Stansted and took over the leases on the six Boeing 737s. It also sub-leased four of the BAe 146s from KLM, and relaunched the operation as a wholly-owned subsidiary called Buzz Stansted. The first revenue services were flown on 28 April 2003. The majority of the fleet retained their original Buzz livery, and were also used on some of the main Ryanair routes, but the BAe 146s were returned to KLM in January 2004 and in September of that year Ryanair announced its decision to close down Buzz Stansted. The last services were flown on 31 October 2004. In the meantime, the airport had been involved in yet another hijacking. On 6 February 2000, a Boeing 727 of the Afghan airline Ariana on an internal flight from Kabul was seized and flown via Tashkent, Kazakhstan and Moscow to Stansted, where it landed at 0202hrs on 7 February. The aircraft, with over 140 passengers aboard, spent three days in a secure area at the northern end of the airport while negotiations went on. Eventually, the stalemate ended peacefully with the surrender of the hijackers and the release of all on board. By 2000, the main terminal had already exceeded its original design capacity of 8 million passengers per year and work commenced on a five-year expansion programme. This included a £60 million extension to the main terminal building and the construction of two further satellite lounges on the apron. In November 2000, BA chief Rod Eddington announced that the airline was planning to sell off Go Fly as it was diluting BA's revenue on many of its full service routes. During its two years of operation Go Fly had made losses of £20 million each year but it was moving towards profitability, and in June 2001, it was the subject of a management buy-out led by Barbara Cassani with the co-operation of venture capital company 3i, the price of £110 million being paid for the airline. By December 2001 Go Fly was able to report that its passenger loads were up 57.3 per cent on the previous December and that its fleet had grown to twenty-eight Boeing 737s. Despite this progress, however, on 16 May 2002 Easyjet announced that it was buying Go Fly for £374 million. The final Go Fly service under its own name was flight 226 from Nice to Stansted on 29 March 2003, and from April all services were operated under the Easyjet banner.

In May 2001, new UK start-up airline Blue Fox Executive Airlines announced its plans to start a twice-daily Stansted–New York (JFK) scheduled service in March 2002. The flights were to be operated by Boeing 767-300ER wide-bodied aircraft in a 138-seat all-Business Class configuration. Fares were to start at £1,200 return, helicopter links to central London were to be offered for a supplement, and the company's business

plan envisaged break-even by the third year of operation at a 50 per cent load factor. Additional routes to Washington and Boston and to Los Angeles and San Francisco were to be added at nine-monthly intervals, but nothing was to come of these ambitious plans. Other airlines, however, were successful in their more modest expansion plans, including Eastern Airways, which introduced Manchester–Stansted weekday flights during the summer of 2003. In May 2005, Flyglobespan launched twice-daily flights from Stansted to Glasgow and Edinburgh in competition with Easyjet. Fares were as low as £19.99 one way including taxes, and the airline also offered flexible Business fares from £59 one way including taxes, but the service was withdrawn in February 2006.

2005 saw the return of scheduled transatlantic services from Stansted, this time by not one but two new airlines, both of which chose to concentrate on the premium business travel market. On 25 April, MAXjet Airways inaugurated New York (JFK)–Stansted services using Boeing 767-200s in an all-Business Class layout for 102 passengers at a fare of £854 return. The New York route was followed on 2 November 2006 by a route from Las Vegas to Stansted, and flights were also operated from Washington. In June 2007, MAXjet was claiming an 83.1 per cent load factor on its services from Stansted, but the airline was only to survive for a few more months. On 7 December 2007, trading in MAXjet shares was suspended, although flight bookings were still being taken. On 24 December, however, the airline suspended all operations and filed for Chapter Eleven bankruptcy protection. Passengers whose travel plans were affected by the closure of MAXjet were rebooked by that airline onto the services of Eos Airlines, which had also commenced New York (JFK)–Stansted flights on 18 October 2005. Eos Airlines used smaller Boeing 757-200 narrow-bodied jets configured to carry just forty-eight passengers, all in Business Class, at the much higher fare of £3,500 return. Between two and four flights were operated each day on the New York route, and in April 2007 Eos announced that new routes to Stansted from Washington, Boston and Los Angeles were planned for introduction within the coming two years. Extra flights from New York, this time from Newark airport, were scheduled to commence from 5 May 2008, and flights from Stansted to Dubai from 6 July 2008, but on 26 April 2008 Eos Airlines announced its intention of filing for bankruptcy. The last scheduled services operated were flight EO6 from New York to Stansted and flight E07 back to New York, both on 28 April, but there was also a charter flight 9805, which departed Stansted for New York on the evening of 30 April 2008. In the meantime, American Airlines had also launched New York (JFK)–Stansted services in October 2007, but rising costs caused the suspension of these flights on 2 July 2008.

A December 2003 White Paper had stated that the government's policy was to construct an additional runway at Stansted before any more were added at Heathrow, but on 22 November 2007, the government reversed this policy and unveiled plans to build a third runway at Heathrow by 2020 instead. Despite this setback Stansted continued to develop and on 1 July 2008 phase one of the new terminal extension was opened. This provided almost 6,000 metres squared of additional space for arriving

passengers, including a sixth baggage reclaim belt and extra desk space for immigration control, and was part of a £50 million investment in new passenger facilities. On 13 July 2008, four veterans of 'Easy Company', 2nd Batallion, 506th Infantry Regiment of the US Army in the Second World War were the special guests of honour at the official unveiling of a commemorative display at Stansted to celebrate the airport's origins as a wartime airfield. The display consisted of two commemorative plaques that had originally been presented in 1992 to mark the fiftieth anniversary of the construction of the airfield but had been removed from display during the terminal extension work that year. Also unveiled was a new 'The Early Years' display charting the airfield's military history. At 0300 on 8 December 2008, members of the militant environmentalist group Plane Stupid staged a protest at Stansted by cutting through the perimeter fence, hauling concrete blocks and metal fencing onto the taxiway and chaining themselves to it. The airport was out of action until 0815 that day, and Essex Police made fifty-seven arrests. Ryanair was forced to cancel fifty-six flights and many other airlines suffered severe delays. An unusual happening took place during the night of 5/6 July 2009. As a result of a gradual shift in the position of the Magnetic North Pole runway 05/23 at Stansted was redesignated as runway 04/22. During the course of the night all the relevant signage on the airfield was changed, and the numbers on the runway ends were repainted with the new figures.

On 24 May 2010, BAA Stansted announced that it was withdrawing its application for a second runway. A General Election had produced a new coalition government that had given a clear indication that its airports policy would not be in favour of the construction of such a runway in the foreseeable future. Despite this major blow, Stansted continued to expand its range of services, and in March 2011 it was voted 'world's best low-cost airport' in a customer survey and presented with an award at the 2011 World Airports Awards in Copenhagen. At that time, around 150 destinations were served and the airport management claimed to offer more direct scheduled European flights than any other airport.

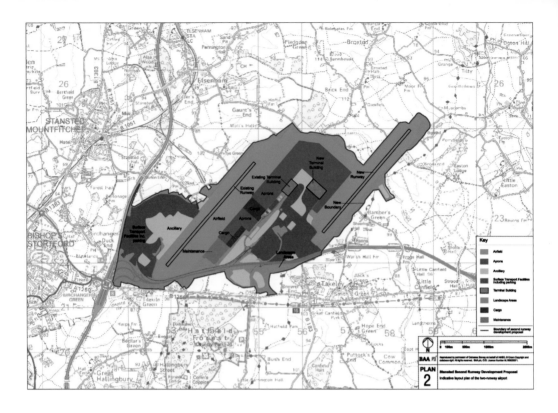

Above: Diagram of the proposed airport layout incorporating the second runway. (BAA)

Left: HM The Queen arrives to open the new terminal building on 15 March 1991. (BAA)

HM The Queen during the official opening of the new terminal on 15 March 1991. (BAA)

0006435

Issued by: CHANNEL ISLANDS TRAVEL SERVICE LTD.

Passenger Ticket and Baggage Check

An Aberdeen-London Express ticket for the Aberdeen-Stansted service in 1994. (Via author)

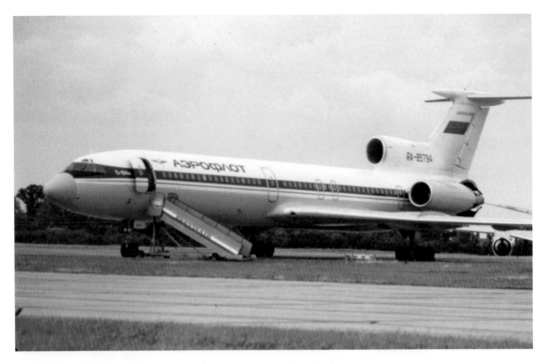

Aeroflot TU-154 RA85794 at Stansted in August 1995. (Author)

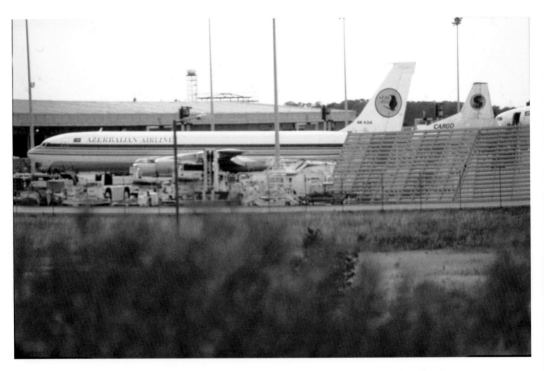

Azerbaijan Airways Boeing 707 freighter 4K-AZA in the cargo area in 1995. (Author)

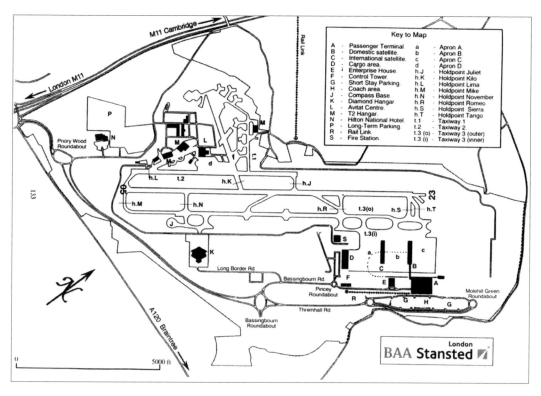

The layout of the airport in 1997. (BAA)

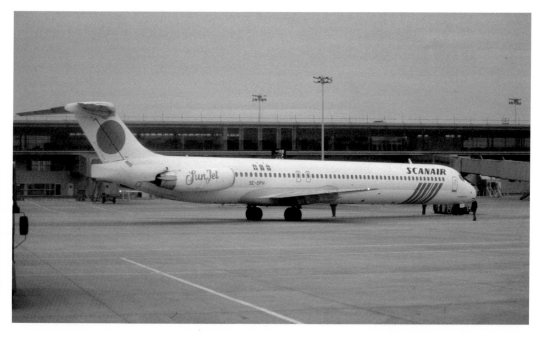

Scanair DC-9-80 'Sun Jet' SE-DPH at Stansted on one of the numerous Scandinavian charter services. (Eric Melrose)

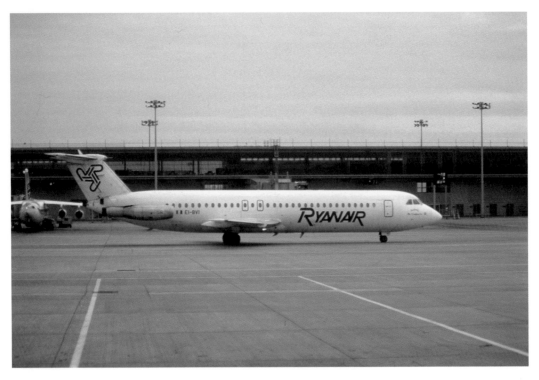

One-Eleven EI-BVI, one of the early Ryanair jets at Stansted. (Eric Melrose)

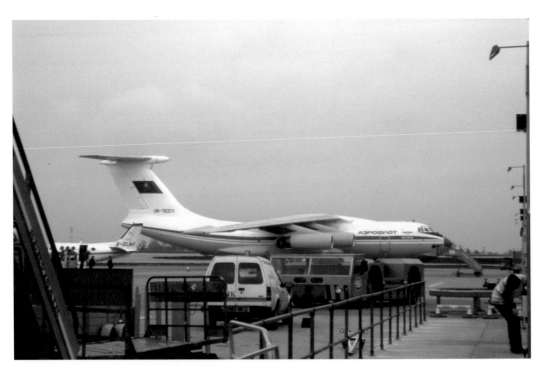

Aeroflot IL-76 UN-76371 on a cargo charter. (Eric Melrose)

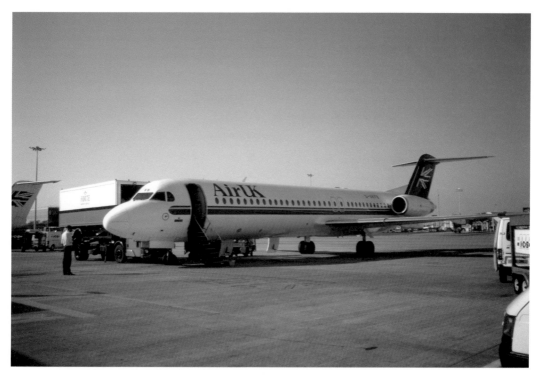

Air UK Fokker 100 G-UKFB on turnround at Stansted. (Eric Melrose)

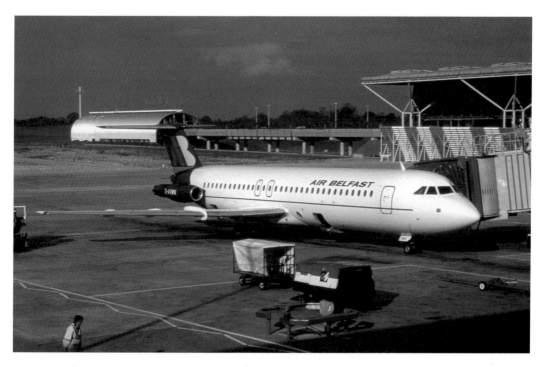

One-Eleven G-AVMN of Air Belfast in 1995/96. (Eric Melrose)

Former British Airways Trident 3 G-AWZU, which was acquired by the airport fire service in March 1986. (Eric Melrose)

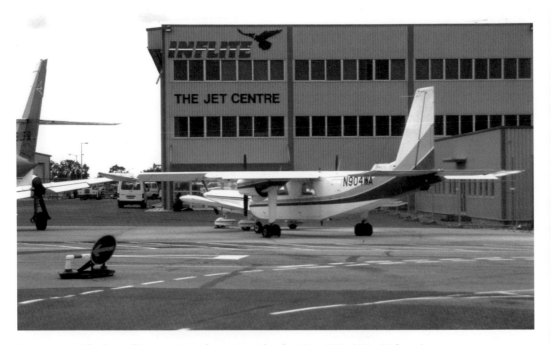

A scene outside the Inflite premises, featuring Islander N904WA. (Eric Melrose)

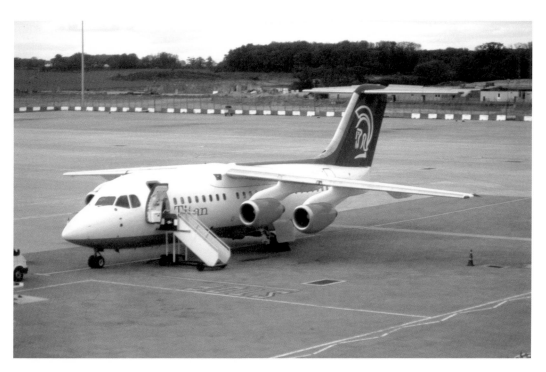

BAe 146 G-ZAPL of resident operator Titan Airways. (Eric Melrose)

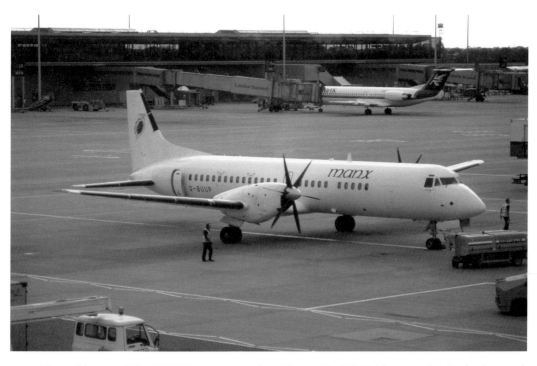

Manx Airways ATP G-BUUP on its stand, with an Air UK Fokker 100 in the background. (Eric Melrose)

Two Shorts 360s and an ATR-42 of Stansted-based Titan Airways. (Eric Melrose)

Gill Air operated certain routes out of Stansted for Air UK, using ATR-42s such as G-ORFH. (Eric Melrose)

Air UK Fokker 50 G-UKTD, the replacement for the F-27 in Air UK service. (Eric Melrose)

Air UK BAe 146 G-UKAC taxies in at Stansted. (Eric Melrose)

BAe 146 G-UKSC of resident low-cost carrier Buzz. In the background can be seen a Titan Airways Boeing 737 and another belonging to Ryanair. (Eric Melrose)

Buzz BAe 146 G-BTTP taxies out. This aircraft was formerly in service with Air UK. (Eric Melrose)

UPS Boeing 767 freighter N319UP in the cargo area. (Eric Melrose)

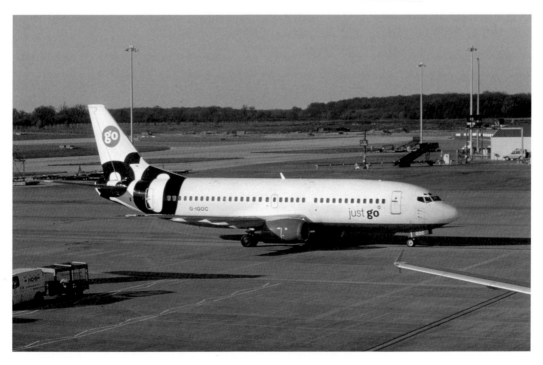

Boeing 737 G-IGOC of Go Fly taxies onto its stand. (Eric Melrose)

Modified Piper Aztec N4422P in the executive aircraft area in September 1999. (Author)

Former Classic Airways Lockheed Tristar G-IOII at Stansted after the airline was grounded in 1998. (Author)

Tristar G-IOIT at Stansted in September 1999 after the grounding of its former operator Classic Airways. (Author)

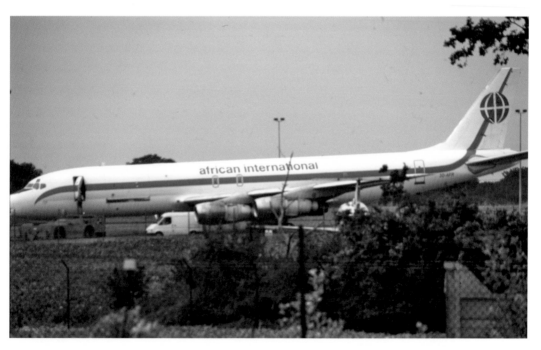

African International DC-8 freighter 3D-AFR at Stansted in September 1999. (Author)

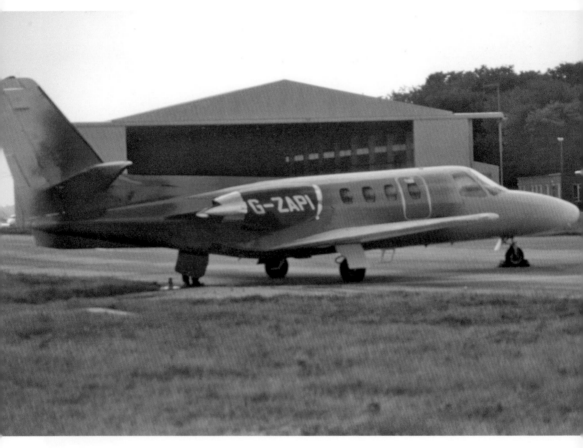

Titan Airways Cessna Citation G-ZAPI in September 1999. (Author)

A view along the Stansted taxiway. (Richard Flagg)

A view looking down runway 22 at Stansted. (Richard Flagg)

The Ryanair hangar at Stansted. (Richard Flagg)

The SR Technics 'Diamond' hangar at Stansted up for sale or lease. (Richard Flagg)

An aerial view of the airport from a departing Ryanair Boeing 737. (Richard Flagg)

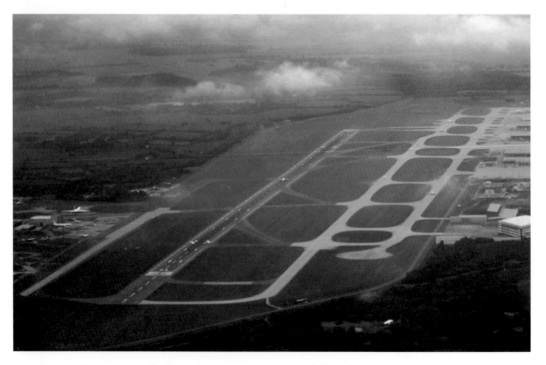

Aerial view of Stansted, with the maintenance area on the left and the terminal complex on the right. (Richard Flagg)

An atmospheric sunset view from the new terminal building towards the new control tower. (BAA)

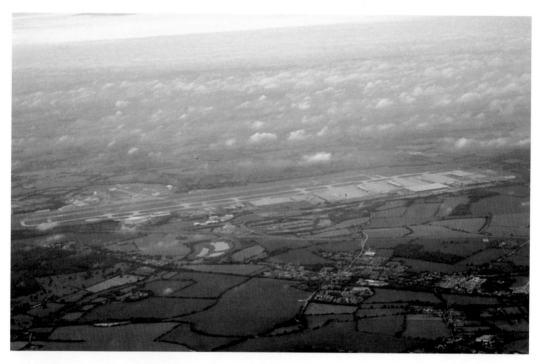

An aerial view of the whole airport in its rural setting. (Richard Flagg)

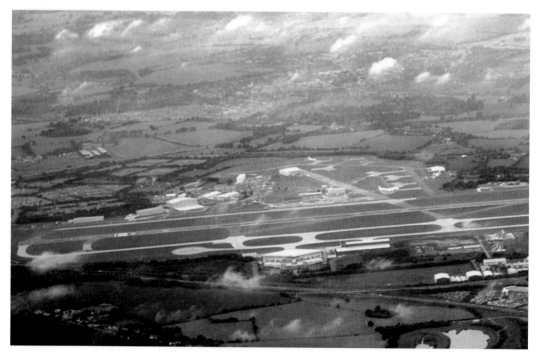

An aerial view of Stansted, with the maintenance area on the far side of the runway. (Richard Flagg)

The Inflite Jet Centre at Stansted. (Richard Flagg)

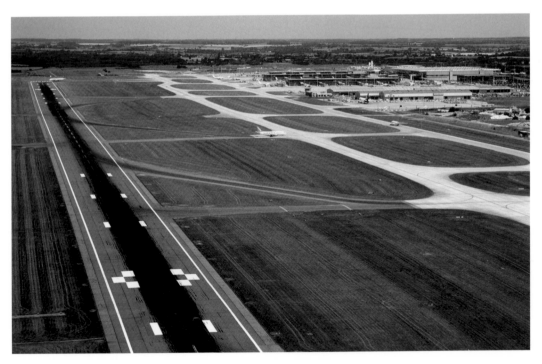

An aerial view along runway 05, with the new terminal facilities on the right. (Via author)

A busy summer scene inside the new terminal building in 2002. (BAA)

The interior of the FLS Diamond Hangar, with Boeing 737s of various operators receiving attention. (Dan Nicholson)

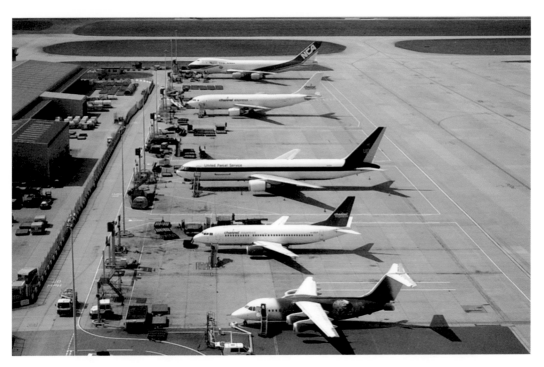

The new cargo terminal and apron seen from the new control tower, with freighters of Titan Airways, Channel Express, UPS and Nippon Cargo Airlines present. (Dan Nicholson)

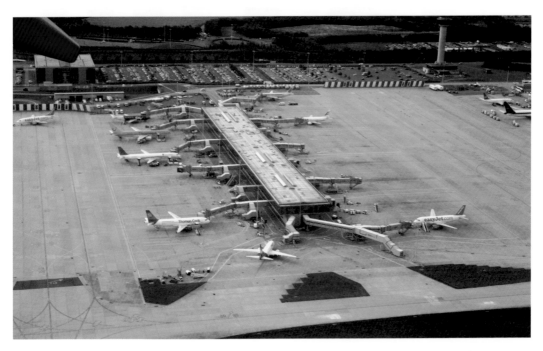

Aerial view of one of the satellites of the new terminal building and the new control tower, seen from a departing aircraft. (Dan Nicholson)

Two examples of posters produced by the 'Stop Stansted Expansion' campaign. (Via author)

STOP
STANSTED
EXPANSION

NO
SECOND
RUNWAY

STOPSTANSTEDEXPANSION.COM
01279 870558

info@stopstanstedexpansion.com
www.stopstanstedexpansion.com

Four Ryanair Boeing 737s on their stands at Stansted, with EI-DAJ nearest. (Eric Melrose)

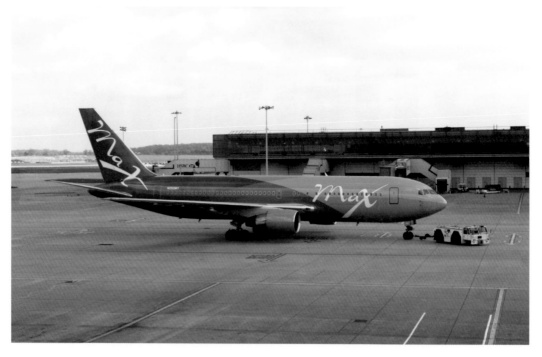

MAXjet Boeing 767 N250MY on pushback at Stansted. (Eric Melrose)

Air Berlin Boeing 737-700 D-ABAA taxies in past some work in progress. (Eric Melrose)

A typical scene at Stansted as three Easyjet Boeing 737s taxi out behind a Ryanair example. (Eric Melrose)

Advertisement for Flyglobespan's services from Stansted to Glasgow and Edinburgh in 2005–06. (Via author)

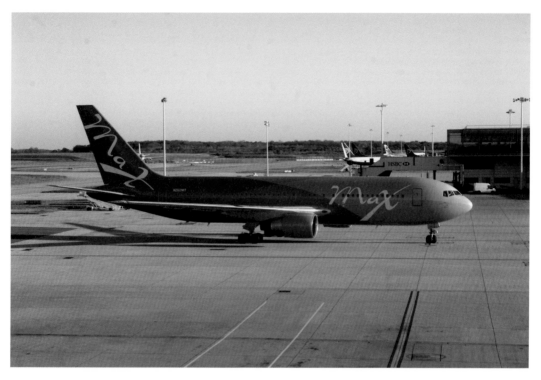

MAXjet Boeing 767 N260MY taxies in to the terminal. (Eric Melrose)

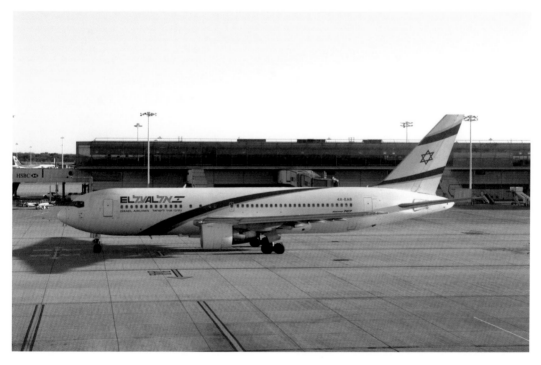

El Al Israel Airlines Boeing 767 4X-EAB departs on another Tel Aviv service. (Eric Melrose)

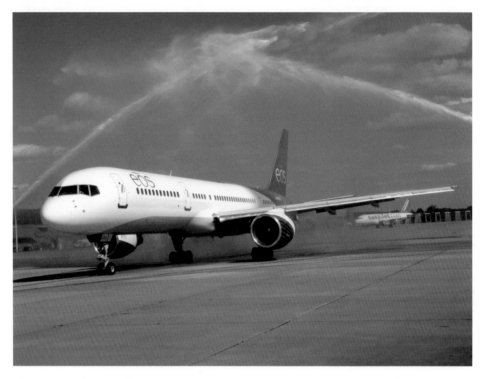

The inaugural Eos Airlines Boeing 757 service to Stansted is greeted with a water arch provided by the airport fire service. (BAA)

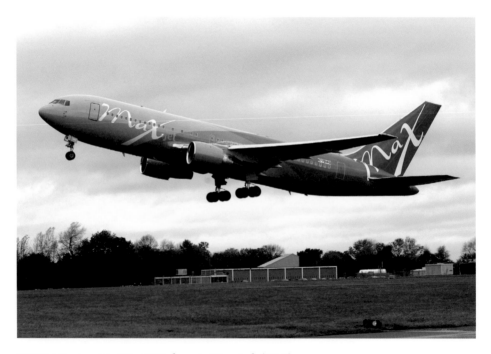

MAXjet Boeing 767 N770WD departs Stansted. (BAA)

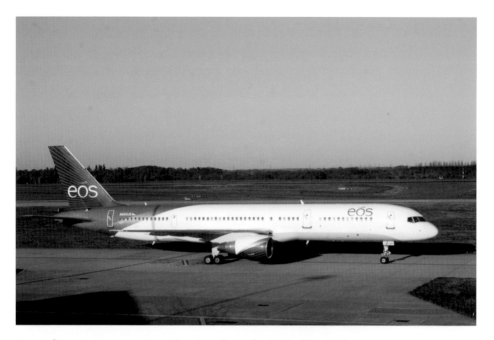

Eos Airlines Boeing 757 N405JS arrives from the USA. (Eric Melrose)

The visit of four veterans of Easy Company of the wartime US Army for the unveiling on 13 July 2008 of a new commemorative display marking Stansted's wartime origins and operations. (BAA)

Air Force One, the US Presidential Boeing 747, at a misty Stansted during President Obama's visit to the UK for the G20 Summit in March 2009. (BAA)

A truckload of TV transmission equipment is loaded into an Antonov 124 for shipment to South Africa for use in coverage of the June 2010 Football World Cup. (BAA)

Also available from Amberley Publishing

GRANT PEERLESS *&* RICHARD RIDING

LEAVESDEN AERODROME

FROM HALIFAXES TO HOGWARTS

Also available from Amberley Publishing

RIVENHALL
THE HISTORY OF AN ESSEX AIRFIELD

BRUCE STAIT
Edited by ANDREW STAIT